Supported by
TATE MEMBERS

Published by order of the Tate Trustees on
the occasion of the exhibition at Tate Modern
17 February – 15 May 2005

First published in 2005 by Tate Publishing,
a division of Tate Enterprises Ltd, Millbank,
London SW1P 4RG
www.tate.org.uk/publishing

British Library Cataloguing in Publication Data
A catalogue record for this book is available from
the British Library

ISBN 1 85437 562 8

Distributed in the United States and Canada
by Harry N. Abrams, Inc., New York

Library of Congress Cataloging in Publication Data
Library of Congress Control Number:
2004111331

Catalogue design by Peter B. Willberg
at Clarendon Road Studio, London
Printed and bound in Belgium by Die Keure

Cover: *Sunset over the Sea* 1903 (no.41, detail)
Frontispiece: *Self-Portrait* 1906–7 (no.80)

Measurements of artworks are given in
centimetres, height before width and depth,
followed by inches in brackets

All letters reproduced in the Plate Section
are from *Strindberg's Letters*, II: 1892–1912,
trans. Michael Robinson, London 1992

August Strindberg

August Strindberg

Painter, photographer, writer

Olle Granath
with contributions by David Campany, Helen Sainsbury and Göran Söderström

TATE PUBLISHING

Contents

Supporters' foreword

Tate Members are delighted to support the first major British exhibition to focus on paintings and photography by the Swedish polymath August Strindberg (1849–1912). Strindberg has emerged in the latter half of the twentieth century as a precursor of modern art, although his work in the visual arts remains largely unseen in the UK.

Tate Members was founded in 1958 specifically for individuals to support the work of Tate, and contributes funds for the purchase of works of art for the Collection of British and International Modern Art on behalf of the nation, as well as money for educational and interpretative projects, family and access programmes and, more recently, for exhibitions.

August Strindberg is the fourth exhibition that Tate Members have sponsored at Tate Modern, the first being *Eva Hesse* in 2002, followed by *Donald Judd* in 2004 and *Luc Tuymans* in the same year. In 2004 Members also supported the exhibition *Gwen John and Augustus John* at Tate Britain, *A Secret History of Clay: from Gauguin to Gormley* at Tate Liverpool and the winter season at Tate St Ives.

For the third year running Members are committed to giving over £1 million in annual support to Tate. In addition, the Members recently played a significant role in helping Tate establish a permanent fund to generate income and to build and develop the Collection by committing a further £1 million to the fund at its launch. This only serves to reinforce how central Members are to the success of all four galleries and the vital role they play in helping Tate fulfil its duty to collect and conserve art for the nation. We hope that many of you who view the exhibition and read this catalogue will join us in supporting Tate's vision of increasing knowledge, understanding and enjoyment of art and, in return, enjoy the many benefits of membership.

Lady Hollick CHAIR, TATE MEMBERS

Foreword

Most people would be happy to excel in one particular field of work but August Strindberg seems to have accepted no such limits. Now celebrated as one of the fathers of modern theatre, Strindberg was an immediate success as a writer of novels and plays but his immense curiosity and imagination led him on to experiment with painting, photography, alchemy and the natural sciences.

Although Strindberg seems to have turned to painting as an alternative means of expression at times of personal difficulty, it is evident that he took his work in the visual arts just as seriously as his writing, resulting in an extraordinary body of work. Although he associated with fellow artists in Stockholm, Berlin and Paris, Strindberg developed his own independent and radical approach to painting and photography.

Taking the landscape around the Stockholm Archipelago as his subject, Strindberg began painting in the 1870s but then put aside his palette for almost twenty years. When he returned to painting in the 1890s a remarkable shift had occurred in his practice. Although the sea was to remain his primary subject, the compositions were pared down almost to the point of abstraction and he began to engage with the materiality of paint in a way that had more in common with twentieth-century developments such as Abstract Expressionism than with the art of his contemporaries.

Strindberg believed that chance played a vital role in the creative process and explored this concept in his seminal essay, *New Arts! or The role of chance in artistic production*, reproduced in this catalogue. Published in 1894, the essay shows Strindberg contemplating ideas that were to become central to the theory of the Surrealists some twenty years later.

Strindberg's work in the visual arts remained largely unseen until the 1970s and it is hard to establish exactly how much his work can have influenced artists practising in the twentieth century, yet many of his ideas and images seem extraordinarily modern. This exhibition is an exciting opportunity to see Strindberg's work in the context of a modern art museum and is the first of a new strand of exhibitions at Tate Modern, which aim to examine the roots of art in the twentieth century.

To coincide with the exhibition at Tate Modern, the Cottesloe Theatre presents Caryl Churchill's new adaption of Strindberg's *A Dream Play*, produced by Katie Mitchell. We are delighted to collaborate with Nicholas Hytner, Director of the National Theatre, in bringing the diverse talents of August Strindberg to the attention of a British audience.

The exhibition would not have been possible without the expertise of Olle Granath, to whom we are extremely grateful for gathering together the most comprehensive exhibition of Strindberg's paintings to date. We are also grateful to Hans Dyhlén, Lord Poltimore, Lars Gundberg and Tom Österman for their assistance in tracing and contacting the owners of important works, some of which have not been exhibited for many years. Thanks are also due to Katarina Ek-Nilsson and Erik Höök of the Strindberg Museum, Anna Bodin and Arvid Jakobsson at the Royal Library of Sweden, and Barbro Ek at the Bonnier Archive for their invaluable assistance in researching the exhibition. Last but by no means least, we are greatly endebted to the many museums and private collectors who have so generously lent to the exhibition. Strindberg is known to have made only about 120 paintings and, due to the rarity of his works, many collectors have been asked to part with a large number of works. We are immensely grateful to them for making this sacrifice.

The catalogue, elegantly designed by Peter Willberg, has benefitted from excellent contributions by Olle Granath, David Campany and Göran Söderström, offering new insights into the work of Strindberg. We would like to thank Nicola Bion for her skilful management of the catalogue, as well as her colleagues in Tate Publishing, especially Alessandra Serri and Emma Woodiwiss. We are also grateful to Silke Klinnert and Oliver Klimpel for contributing their expertise to the design of the exhibition.

We would like to thank the Embassy of Sweden for providing financial assistance in the making of an English version of Anders Hanser's film, *Strindberg: Painter and Photographer*, to be shown in the exhibition. We are also grateful to the Swedish Institute for providing additional support for this project. We would particularly like to extend our thanks to Johanna Garpe, Counsellor for Cultural Affairs at the Embassy of Sweden, for her enthusiastic support of our activities.

At Tate Modern, curator Helen Sainsbury has worked alongside Olle Granath to bring the exhibition to completion, as well as providing catalogue entries for key works in the exhibition. The complexities of delivering the exhibition have been ably handled by assistant curator, Vincent Honoré, curators of interpretation, Jane Burton and Simon Bolitho, registrars Nickos Gogolos and Kia Hing Fay, exhibition manager Stephen Mellor, senior art handler Glen Williams and his team, and conservators Patricia Smithen, Calvin Winner, Elizabeth MacDonald and Elisabeth Andersson. We are also grateful to all those who have contributed to the wide range of activities that support the exhibition, including Catherine Clement, Emma Clifton, Stuart Comer, Ruth Findlay, Jennifer Lea, Phil Monk, Caroline Priest, Sheena Wagstaff and Dominic Willsdon.

Vicente Todolí DIRECTOR, TATE MODERN

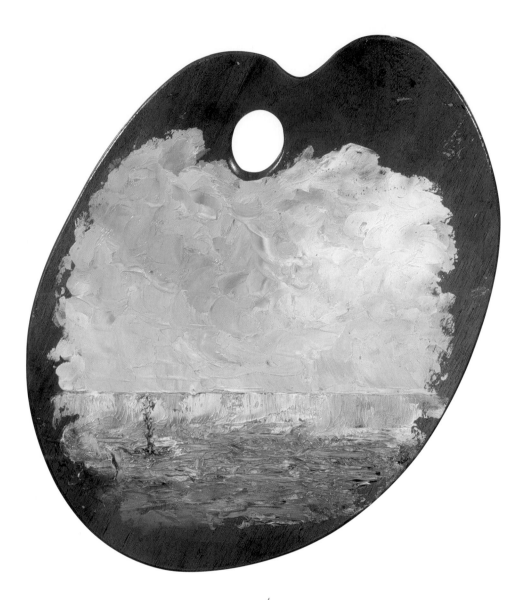

Palette with Solitary Flower on the Shore
1893
Oil on wood, 38 × 34 (15 × 13 3/8)
Private collection

A writer's eye OLLE GRANATH

These naked walls were those of the cell of a mediaeval monastery where visual
asceticism and an empty environment drove a starving imagination to gnaw at
itself, to conjure up brighter or darker images merely to escape from nothingness.
The white, formless, colourless nullity of these lime-washed walls dragged to the
surface a pictorial urge which primitive man's cave or arbour has never evoked,
which the forest, with its ever-changing colours and mobile contours has made
unnecessary – an urge never produced by either the plain or the moor with their
rich iridescent skies, or the sea, of which we never tire.

(From *By the Open Sea* [*I Havsbandet*], 1890, trans. Mary Sandbach, London 1984)

No reader of Strindberg can fail to notice the precision with which he graphically describes his
surroundings, whether countryside, city, homestead or the stage. His sharp observations provide
the reader with a mass of detail: measurements and scales, entrances and exits, the colour and
quality of materials, light conditions, orientation using points of the compass. He calls upon all our
senses to hear sounds, smell scents and feel hard or soft, hot or cold, damp or dry. Where many
other writers might look for one word to sum up the mood of a place, Strindberg builds his
atmospheres through precise, detailed observation. This might well be an educated naturalist's way
of describing the world, but for Strindberg it was never a literary programme, his sensuality being
saturated in knowledge about what he was seeing.

As a youth this thirst for information had driven him out to experience the natural world for
himself, handbooks on flora, fauna and geology in hand. No field of knowledge was foreign to him
or exempt from his constant, critical questioning. From this point of view his early years in
Stockholm as an assistant librarian at the Royal Library had provided him with resources he had not
found at Uppsala University: while at work he could easily search for the answers to most of the
questions that crossed his inquisitive mind. This hunger for knowledge, with its sometimes
preposterous questioning, was to reach its climax with his *Blue Books*, written towards the end of his
life – books that are anything but a mere summing-up of his life's accumulated experiences. In them
he continued to expand his spheres of knowledge, testing, rejecting, blaspheming and believing. The
Blue Books are the sublime expression of an indomitable mind determined to understand the world
on its own terms rather than be guided by the truths of others. By then this truth-seeker had already
been through occultism, alchemy, Emmanuel Swedenborg, attempts to overthrow some of the
very foundations of natural science, and a struggle with the God who had all but converted him to
Catholicism. Those around Strindberg – and even the man himself – had at one time attempted
to have him certified, an ordeal he had survived remarkably unscathed.

His first endeavours with paint and brushes occurred during a brief period under the guidance
of a student friend at Uppsala. How far he developed as an artist at that time, however, we do not

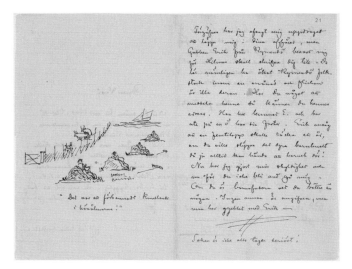

2
Illustrated letter to Carl Larsson (1881–94)
13 April 1882
21 × 27 (8 ¼ × 10 ⅝)
Uppsala University Library

know. The following summer he found himself associating with a group of young Stockholm bohemians, artists he was later to portray in his debut novel *The Red Room* (*Röda Rummet*, 1879). One of them was Per Ekström, the novel's Sellén, and it is hard to imagine that Strindberg did not have another attempt with the brushes in Ekström's studio. Ekström, who came from the Baltic island of Öland, had been quick to adopt a painting technique where light was of prime importance. Under the influence of contemporary French outdoor painting he had gradually developed a personal style in which light dissolved landscape into a flicker by the application of colour to the canvas in flecks of paint – although not in the manner of the Pointillists, as represented some decades later by Seurat and Signac. Over the years Strindberg acquired some of the paintings by this friend from his youth, and there are some similarities, if not major ones, between their paintings.

A few of Strindberg's paintings survive from the 1870s, although none indicates what was to characterise him as a painter. Some of his pencil drawings, however, do remain that reveal the humorist, a side of Strindberg that even in his darkest hours is always lurking round the corner, and the scientist who, pencil in hand, examines plants, various types of landscape and buildings, particularly out in the Stockholm Archipelago. With its capricious seas, its lighthouses and buoy beacons, its many thousands of islands, its austere bedrock and welcoming sandy beaches where low-slung buildings cower against the wind, these would forever remain Strindberg's prime motifs, no matter where in Europe he happened to be painting.

In his autobiographical novel *The Son of a Servant* (*Tjänstekvinnans son*) there are some oft-quoted lines in which the author describes how Johan, his alter ego in the book, is once and for all captivated by the natural beauty of the Archipelago:

> They crept between blueberry wires and juniper bushes until they came to a steep,
> flat rock. Whereupon he saw an image that gave him goose-pimples of sheer
> delight. Islets and bays, reaching far, far away into infinity. Stockholmer though
> he was, he had never before seen the Archipelago, and didn't know where he was.

This vision made the same impression upon him as if he had rediscovered a country only previously seen in dreams, or in some past life, of which he knew nothing but in which he believed.

When Strindberg settled for the summer on the island of Kymmendö in 1870 he made it his favourite place on earth, the object of his longing no matter where his travels took him. Kymmendö and its inhabitants were the subject of his novels *The People of Hemsö* (*Hemsöborna*, 1887) and *Life in the Archipelago* (*Skärkarlsliv*, 1890). If he ever felt unwelcome here, it was because he described them realistically rather than idealising them. But the Archipelago is far-flung and over the years there would be many other places where he would stay: Sandhamn, Runmarö, Dalarö, Blidö and Furusund to name just a few.

When Strindberg turned seriously to writing, having dabbled in a number of other professions, among them acting, it was for the stage. When he was only twenty-one he had succeeded in having his play *In Rome* (*I Rom*) performed on Sweden's national stage – which had earlier rejected him as an actor. But it would be some time before he made his Swedish breakthrough as a playwright. His historical drama *Master Olof* (*Mäster Olof*), about the reformation in Sweden during the first half of the sixteenth century, was written two years later, in 1872, and in the same year was turned down by the National Theatre. It was not until 1890 that it was put on, to become Strindberg's Swedish breakthrough as a writer for the stage. But by then he had rewritten the original prose version in verse, at the same time somewhat toning down the conflict between idealism and pragmatism that had been the crux of the original version.

His real breakthrough as a writer, however, would be *The Red Room*, published in 1879. This novel is a broad contemporary account of Stockholm society seen through the eyes of the author's alter ego: he examines and scathingly exposes the corruption, swindling and hypocrisy of contemporary society, while painting a lively picture of the bohemian life of its artists. It put Strindberg at the forefront of the leading young authors of the 1880s, who admired Emile Zola and Georg Brandes above all others. Naturalism and social criticism were for them what literature was all about.

By this time Strindberg was thirty and had begun his long struggle with Swedish society. *The New Kingdom* (*Det nya riket*, 1882) made uninhibited fun of all the pillars of that society, including the Royal Family and the Church. In *Married* (*Giftas*), a collection of short stories published in 1884, marriage as an institution became his target. This was the last straw: he was prosecuted by the Establishment, nominally for blasphemy against Holy Communion. But Strindberg interpreted it, doubtless with reason, as an attack on his activities as a whole. He took refuge in Switzerland and continued to live there with his family until his publisher prevailed on him to come home and appear in court. Reluctantly he did so, prepared to meet what he was certain would be his greatest defeat hitherto. But he was acquitted, to the triumphant acclaim of all young Swedish radicals. However, the accusation left Strindberg with a distaste for the capital, where he no longer felt welcome; it was another fifteen years before he settled there again.

During this decade Strindberg had his first family, with Siri von Essen. The fact that they had three children does not seem to have greatly affected their nomadic existence between France,

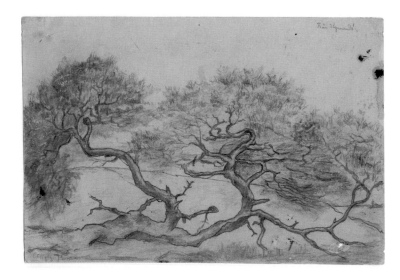

3
Pine 1873
Pencil on paper
16 × 23.2 (6 ¼ × 9 ⅛)
Nordiska Museet, Stockholm

Switzerland, Germany and Denmark. On the other hand, his interest in naturalism, polemical writings and family life left Strindberg little room for painting during the 1880s. As an author, however, despite constant changes of address and marital tensions, he had a highly productive decade. He began his suite of autobiographical novels, *The Son of a Servant*, and in 1887 *The People of Hemsö*, which brought him popular acclaim.

That same year – 1887 – he began to write, in French, *A Fool's Defence* (*Le Plaidoyer d'un fou*), based on the conflicts within his own marriage. In 1889 he moved his family to Copenhagen, where he realised his old dream of opening his own theatre to stage his own plays, with Siri playing the leading roles that she had been refused by other theatres. It was here that *Miss Julie* (*Fröken Julie*) was put on for the first time, with Siri in the lead. Although his finances were severely strained, Strindberg did manage to produce several of the one-act plays he had written during the 1880s, such as *Creditors* (*Fordringsägare*), *The Stronger* (*Den Starkare*) and *Pariah* (*Paria*).

In 1889 his novel *By the Open Sea* (*I Havsbandet*) also appeared. Here for the first time his writing took on a new tone: naturalism gave way to a prose packed with symbols (see p.9) and the problems of society at large were replaced by a more personal struggle. Strindberg had read Nietzsche and was impressed by him: as the 1890s approached, his work demonstrated this new symbolist literary ideal. Young writers who admired his work began to adopt his new ideas; yet Strindberg himself, although sympathetic to them, also began to feel threatened.

It was not until after his devastating divorce, which he described in *A Fool's Defence*, that Strindberg's easel and modelling stand reappear on the scene. He began to despair as one humiliating lawsuit followed another; worst of all, his children were taken from him. As he struggled to cope with his situation, he found that he could no longer write.

In the autumn of 1891 he spent some time on Dalarö with an artist friend who encouraged him to start modelling in clay. Among other things he sculpted a portrait, unfortunately now lost, of his friend. In fact only two of Strindberg's sculptures still survive: both are from later that autumn, after he had moved in to Djursholm and had become acquainted with the Palme family. *The Weeping Boy*,

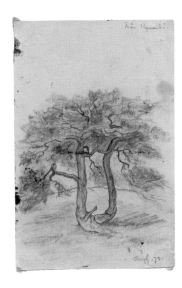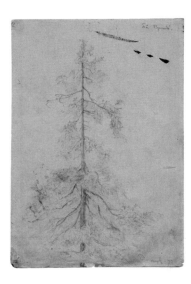

4
Twin Pines 1873
Pencil on paper
15.6 × 10 (6 ¹/₈ × 3 ⁷/₈)
Nordiska Museet,
Stockholm

5
Pine in the Archipelago 1873
Pencil on paper
23.2 × 16 (9 ¹/₈ × 6 ¹/₄)
Nordiska Museet,
Stockholm

intended as a classical paraphrase – a study, in the original meaning of the word – turned, through an accident, into the image of a boy in tears. Perhaps Strindberg, in his state of desolation, saw in it the image of his son, Hans, from whom he had so recently been separated. He gave a full account of what actually happened when this classical statuette was transformed a few years later in an essay about the role of chance in the creative process (see p.131). His other surviving sculpture is a portrait of Hanna Palme, whose family was among those who had taken him, an unhappy author, into their home. Strindberg pointed out that in this portrait he was not striving for a realistic likeness, wishing instead to recreate her demeanour. Contemporary testimony indicates that he succeeded.

Strindberg's first articles about painting were published in the daily papers in Stockholm in 1872. In these early writings he concentrated on the discussion and analysis of subject matter, motif, theme and narrative, as opposed to the painter's methods. His artist friends had criticised him for this, so when he made a comeback as an art critic in the newspaper *Dagens Nyheter* in 1874 he demonstrated that he had taken their criticism to heart by writing competently about the treatment of colour and light as well as about composition. He defended works of art regarded as challenging the tastes and morals of the day in language revealing his familiarity with artists' studio talk.

It was his trained artist's eye that encountered the Impressionists for the first time, at Durand-Ruel, on his first visit to Paris in the autumn of 1876. The admiration in his account of his impressions of 'Monney' (*sic*) and Sisley in *Dagens Nyheter* is not without reserve; yet his description reveals how well he understood these artists' ambitions to capture the movement and changeability of scenes and light. His observations were correct, even if he did not always accept unreservedly the consequences of what he saw.

After his first attempts at art criticism in the late 1870s, it was almost two decades before Strindberg again published articles on art. On 15 November 1894 the readers of the *Revue des revues* were presented with his essay, 'Des arts nouveaux! ou Le hasard dans la production artistique', written in the author's own French (p.131). The ideas he presented here have many historical precursors, and one might have expected this well-read author to have made some reference to, for

6
Hanna Palme von Born 1891
Plaster, 18.5 (7 ¼) high
Private collection

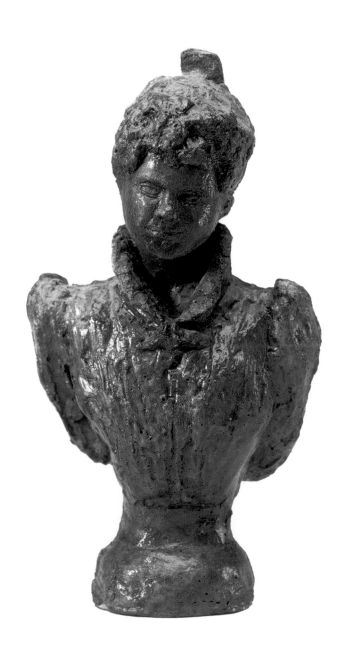

example, Leonardo da Vinci. Instead, he concentrated solely upon the present and his own experiences as a sculptor, painter, musician and observer of nature.

The real value of Strindberg's essay is its lack of prejudice and its open attitude to art. Working with brushes and colour he was open to the intervention of chance, of unexpected forms and figures appearing in the painting. Strindberg explains his search for figures in half-charred pieces of charcoal or the crease of a pillow, no less than his curiosity about the texture of various materials that made him experiment with *frottages* (rubbings) long before Max Ernst made this a concept in modern art. It is also in this text that he makes his oft-quoted claim for the tools he uses:

> So: using the palette knife to this end – I don't own any brushes – I distribute the colours across the panel, where I mix them to arrive at something somewhat reminiscent of a drawing.

Here, as so often elsewhere, Strindberg must be taken with a pinch of salt. Elsewhere he asks for help, financial and otherwise, to buy brushes, paints and panels. In all their elaborate detail his studies of archipelago plants, with which he was so familiar from earlier botanical studies, could hardly be captured with a palette knife alone. On the other hand, it is true that he developed an advanced technique to give the surface its intrinsic dynamic expression, while at the same time allowing for coincidence: this, in turn, demanded a high degree of concentration. By the time Strindberg wrote these lines he had already long been aquainted with Gustave Courbet's use of the palette knife. Some sixteen years earlier, in an article concerning Swedish and French landscape painting, he had written:

> Courbet laid down his brushes and pasted with his knife. All great painters have been deeply involved in their art, without for that sake getting stuck on technique, which in no way kills the spirit but, on the contrary, releases it, if there is any.

These lines would no doubt have struck a chord fourteen years later, when he himself picked up the palette knife.

Strindberg spent the summer of 1892 on Dalarö where, equipped with all the necessary materials for painting, he awaited the outcome of his divorce case. His finances were at rock bottom, and he found himself still unable to write. Under these circumstances his painting was not only therapeutic, it served another, more practical function: as a potential source of income. Another facet of Strindberg's highly complex character was that, faced with the most chaotic and depressing situations, he could draw on the very practical side of his nature. According to Göran Söderström, he produced about thirty paintings on Dalarö that summer. These reveal Strindberg perfecting his technical skills and conceptualising some of the motifs that would remain with him all his life. He made studies of stormy seas, beaches, the light of a Nordic summer night, lighthouses and buoy beacons as civilization's ultimate outposts against the violence of the elements, all of them motifs so deeply etched on his mind that he would be able to recreate them even when they were not in front

7
*Sketch Depicting Partially
Burnt Lumps of Coal* 1896
Charcoal on paper
8.8 × 6 (3 ¹/₂ × 2 ¹/₄)
Private collection

of his eyes. Over the years, several of these well-remembered images formed series, such as the lighthouses, the White Mare seamark, nocturnal storms at sea and solitary plants on a beach. That he later, while in Berlin and Paris, made variations on these themes can rightly be seen as an outburst of longing for the Archipelago – which is not to ignore the practical side of his nature, favouring motifs he was well able to execute. When Strindberg painted, it was invariably with an eye to earning a living. For this reason he held his first exhibition in downtown Stockholm in July 1892, aided and encouraged by his friend Per Hasselberg, the sculptor. At most ten of his freshly-painted canvases were shown. The exhibition could hardly be called a success, either financially or from the point of view of reviews; but no one could fail to notice that from now on Strindberg was not only a writer but also a painter. Caricatures of Strindberg painting in the newspapers helped spread that message.

By the beginning of the 1890s, finding that painting was taking up more and more of his time, Strindberg put his interest in naturalism of the 1880s behind him. Sensitive as he was to fluctuating trends, and concerned at the prospect of being overtaken by younger writers following the lead of the Symbolists, he soon found himself caught up in the maelstrom. For him the 1890s were characterised by the intellectual climate propagated by Symbolism, with its strains of occultism, alchemy and in-depth readings of Swedenborg. He became a Jacob struggling with the angel, at war

8
Frottage Made from the Shell of a Crab 1896
Pencil on paper
9 × 10 (3 ½ × 3 ⁷/₈)
Private collection

with his own era, which he, flung headfirst into the crisis, depicts in his novel *Inferno* (1897) and its sequel, *Legends* (*Legender*, 1897). Knowing as we do that he was now moving towards a more Symbolist approach, we can scarcely fail to see how, even as early as his paintings of Dalarö, Strindberg found a significance in nature far beyond its surface meaning: he used it to symbolise his own feelings. Thus he projected his own state of mind onto agitated waves; the loneliness of his divorce was mirrored in the lighthouse, in sea-tossed buoy beacons and in solitary beach plants. This tendency to endow the countryside and objects with symbolic overtones emerged as early as his novel *By the Open Sea* quoted above. A sounding bell-buoy, for instance, is described thus:

> There it lay rocking on the waves, vermilion-red, damp and shining like an extracted lung, with its great black wind-pipe pointing aslant up into the air. And when a wave next compressed the air, it raised a cry as if the sea were howling for the sun. As its bottom cable ran out it rattled, and then when the wave receded and sucked back the air, a roar arose from the depths that might have come from the giant trunk of a mastodon.
>
> (From *By the Open Sea* [*I Havsbandet*], 1890, trans. Mary Sandbach, London 1984)

His paintings from the summer of 1892 show extreme variations of mood, the violent, pitch-black, nocturnal and rebellious ones side by side with fragile elegies and exquisite depictions of shifting summer light. Onto all he projects his own state of mind. Strindberg is often described as the titan who challenges everyone and everything, from his own friends to the society in which he lived, and even God. The sculptor Carl Eldh portrayed him in his monument outside Stockholm's Strindberg Museum, Strindberg's last home, tethered to a rock and cursing the whole world around him (see p.21). Indeed, in his own work Strindberg frequently refers to Prometheus, the benefactor of mankind as he would have it, punished for his good deeds. No portrait of Strindberg, however, would be complete without reference to his elegiac, romantic nature: a sensitive man, he was easily hurt, never far from tears. His Dalarö paintings from the summer of 1892 encompass extremes of the human character.

In this context the role of music in Strindberg's life should also be mentioned: he taught himself to play the guitar and the piano, and included music in his essay on the role of chance in the creative act. His favourite composer was Beethoven. When he returned to Stockholm at the end of the 1890s, he socialised regularly with the 'Beethoven Guys', a group that included his elder brother Axel, a professional musician. The Beethoven Guys met at Strindberg's place to play music (their repertoire always included Beethoven) and drink toddy.

Having sold just two paintings at his July exhibition, and having been cheated of half of his Dalarö production by a fraudster, Strindberg was receptive to the call of his friend the author Ola Hansson, who lived in Berlin and persuaded him that if he only made his way there, he would get his plays put on. So in the autumn of 1892 he left for Berlin with an advance from one of the proposed theatres in his pocket. Before long he had become a familiar figure at the bar he dubbed '*Zum schwarzen Ferkel*' (the Black Piglet) where, shortly after his arrival, he was a close witness to the so-called Munch Affair. Another member of the group that met at the bar was the Norwegian artist Edvard Munch, whose first exhibition in the German capital was closed down by a scandalised art establishment. Strindberg naturally defended the rejected Munch who, however, was wise enough to make the most of the publicity generated by the scandalous closure: he rented his own exhibition space and reopened in December. His portrait of Strindberg was included in the show.

In Berlin Strindberg continued to paint in the spirit of his Dalarö work. Apart from his *Palette with Solitary Flower on the Shore* 1893 (no.1) many of these paintings were lost during the Second World War, as was the large version of *The Wave* which he had left behind at *Zum schwarzen Ferkel*.

On New Year's Eve 1893 the 44-year-old Strindberg met the 21-year-old Austrian cultural journalist Frida Uhl. In May they were swiftly married on the island of Helgoland. Their honeymoon took them to London, where their frequent disagreements prompted Strindberg, poor as ever, to escape to the island of Rügen, where he met up with some old friends from the *Ferkel*. One of the reasons why he had felt uncomfortable in London was that, although more or less fluent in both French and German, he hardly spoke a word of English and was therefore completely dependent on his new wife.

Before he left London Strindberg would certainly have attempted to see the paintings of J.M.W. Turner. In an article he wrote in the 1870s, when he could not have seen Turner's work other than in reproductions, he had expressed his enthusiasm for it. Five years after his one and only visit

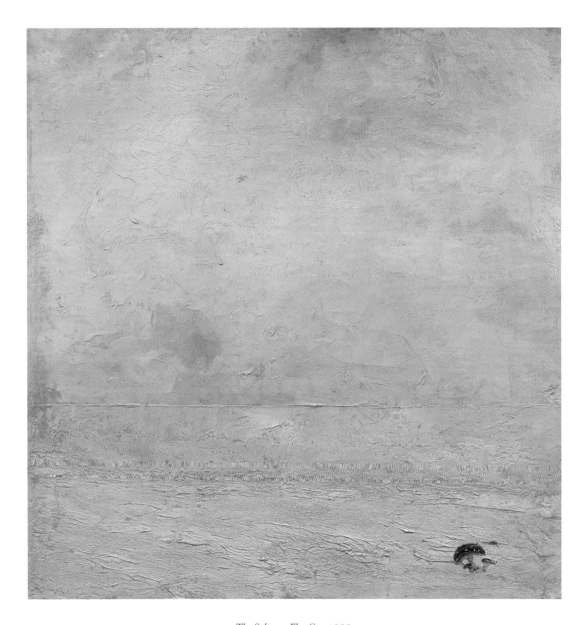

The Solitary Fly-Cap 1893
Oil on paper mounted on canvas, 47 × 45 (18 ½ × 17 ¾)
Private collection
[Not exhibited]

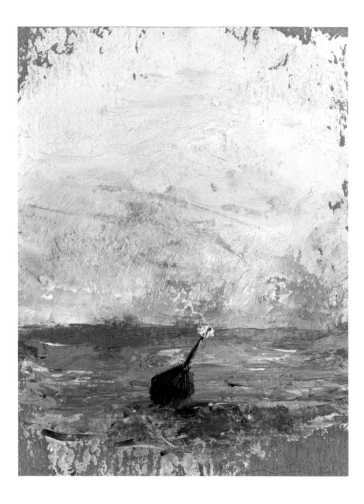

9
The Sounding Buoy 1892
Oil on paper
8 × 6 (3 ¹/₈ × 2 ¹/₄)
Private collection

to England, asked in an interview who his favourite English artist was, he named Turner without hesitation. Among the property he left in the Royal Library in Stockholm are two reproductions of Turner's paintings, although it is not known exactly when they came into his possession. There is little other than these scanty facts to corroborate Strindberg's interest in Turner. It remained to see whether, after the visit to London, his style changed to reflect Turner's influence.

His next phase of painting was in Dornach, Austria, where he was reunited with his pregnant wife at her parents' house by the banks of the Danube. A small house in the grounds was put in order and decorated for the couple as they awaited their child's birth. Strindberg painted pictures so that, in his own words, there would be something beautiful for the newborn baby – a girl, Kerstin – to look at. In these paintings, *The Verdant Island* (no.68), *The Danube in Flood* (no.67) and *Wonderland* (no.62), he strikes a new note. Abandoning the preconceived pictoral solutions he had been carrying with him since Dalarö, his palette now tended towards greens: in this verdure he built up a new spatial sense in which proximity and distance are clearly demarked. The Dalarö paintings show a markedly unified surface. There are two possible explanations for these subtle yet distinct changes in his approach. One might be the impression made by a new, lusher landscape, a different light and the surface of a river with shores on all sides, which in no way acts in the same capricious manner as the

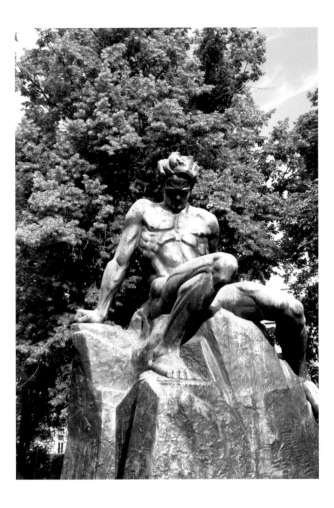

Carl Eldh 1873–1954
The Strindberg Monument
First concept 1916,
erected 1942
Bronze
Tegnérlunden, Stockholm
[Not exhibited]

Baltic of the Stockholm Archipelago. The other reason could be that in London Strindberg had indeed become aquainted with Turner's work.

One of the paradoxes of Strindberg's roving, fluctuating life was his reluctance to give up certain regular habits, such as his long morning walk during which he collected his thoughts and prepared himself for the working day ahead. In Dornach he would return from these morning walks to his new home, filled with impressions from an unfamiliar landscape. Even while walking to collect his thoughts, his natural curiosity would have led him to closely observe his surroundings as he went, and his observations alone might account for the difference in expression in the Dornach paintings. But there is good reason to suppose that he was profoundly influenced by his newly-acquired impressions of Turner. His work now showed deeper perspective, subtler distinction between land and water than in his archipelago paintings. The shorelines and vegetation are harder to distinguish from their reflections in the river. This technique, in Turner as well as Strindberg, was the forerunner of Monet's close-fitting, sensual weave across the canvas in his waterlily paintings, where there is no longer any up or down, nor visible border between objects and their reflections.

During the early 1890s Strindberg devoted an increasing amount of his energy and writings to refuting some of the basic truths of science. Among other things he questioned the periodic

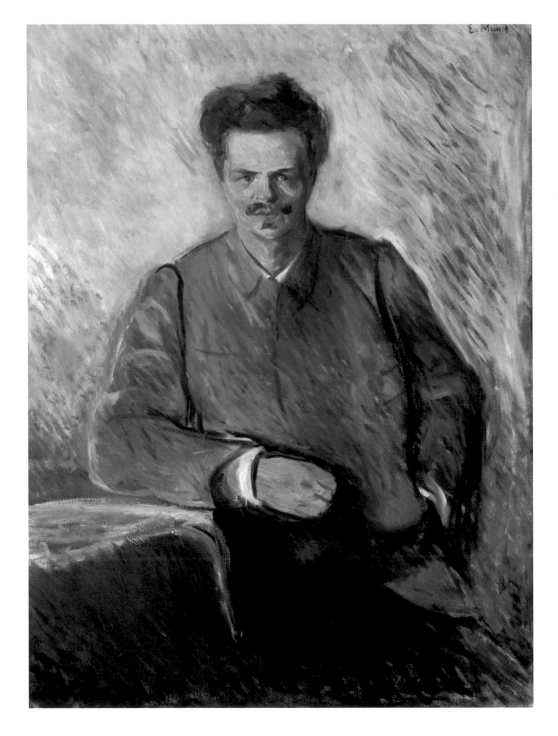

10
Edvard Munch 1863–1944
August Strindberg 1892
Oil on canvas
122 × 91 (24 × 35 7/8)
Moderna Museet, Stockholm.
Gift 1934 from the artist.

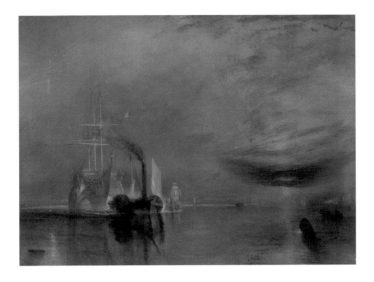

11
Reproduction of a painting by Turner
(The Fighting Temeraire), n.d.
Lithograph, handcoloured
22 × 29 (8 ¾ × 11 ⅜)
The Royal Library, National Library
of Sweden, Stockholm

system of indivisible elements: he was convinced that he could prove that sulphur contained carbon, and that the indivisible elements were made up of primeval matter which, in certain combinations, gave rise to the multiplicity of nature. He was not alone in entertaining such theories at that time: known as 'monism', this approach was common among scientists inclined toward mysticism. With such conviction, it is not surprising that Strindberg believed he could make gold, if he could only find the right combination of primeval matter. In 1894 a summary of his research and opinions was published in German in his book *Antibarbarus*; it was not published in Swedish until 1906. In addition to several essays in scientific and quasi-scientific journals he was to write yet another book, *Sylva Sylvarum* (1895), in which he expounded his theories on an alternative form of science.

From the point of view of modern science these writings are no more than curiosities. Yet, as was so often the case with Strindberg, they possess a poetry that transcends the actual objective of his research. His scientific studies are as it were an attempt to prove what he had already discovered in his art; or, conversely, they had their proof, indeed their very apotheosis, in his paintings. It is quite conceivable that, swept up in the act of painting, Strindberg experienced himself as realising his monism by raising a craft to the level of poetry, his painting reconciling earth, sea and sky into a single element. That he was familiar with such ideas can be seen in his essay on chance where he describes how his painting *Wonderland* (no.62) came into being:

> With the slightest touch of my finger here and there, I mix the colours that
> are at odds, merge them, ridding them of their harsh tones, thinning them out,
> dissolving them, and there it is – done!

Strindberg was a master at making bold syntheses in his work. After years of experimentation, writing scientific articles, correspondence and impassioned discussion with other scientists, he jotted down the following on a scrap of paper: 'Gold is Sunlight photographed and fixed', a statement that rings true like a fine line of poetry.

Before long he felt compelled to escape mounting tensions within the Dornach family idyll. He returned to Paris, where he borrowed an elegant apartment in the Passy district put at his disposal by a Danish artist named Willy Gretor. Having been initially charmed by this man, Strindberg soon discovered that he was involved in fraudulent dealings and even had reason to suppose that Gretor was connected with a murder. The distraught Strindberg, embarking on his second divorce within three years, was almost penniless, the literary world apparently closed to him. However, the autumn was not without its successes: Lugne-Poë's production of *The Father* (*Fadren*) at the Théâtre de l'Oeuvre brought public acclaim. But this was to no avail, for he was already falling headlong into the path of the inferno where unknown powers had him in thrall, causing him to hallucinate and feel persecuted.

During the summer and autumn of 1897 Strindberg wrote his two novels, *Inferno* and *Legends*, in which, as we have seen, he described his personal crisis of the 1890s, mainly while living in Paris. At the time he was struggling with feelings of exhaustion and failure after the collapse of two marriages. His finances were in a bad way. His scientific ideas, which he regarded as revolutionary, were not getting the attention he felt they deserved. And for the first – and only – time in his life he was admitted to hospital with chronic eczema on his hands, probably caused by his primitive scientific experiments. He began to show signs of paranoia, interpreting everyday events, items he read in the newspapers, remarks taken out of context and unexpected encounters as moves in a game being played with him by higher powers. Here he was deeply influenced by his readings of Swedenborg. He was now beginning to live out the symbolism that his contemporaries were merely committing to paper. In 1896 he had begun keeping his *Occult Diary* (*Ockulta dagboken*), noting matters large and small and trying to see them as parts of an all-embracing whole. He continued to keep this diary until his death sixteen years later. It shows that he never ceased to be in contact with spirits and 'the powers', to which he ascribed all the strange events that he felt happened to him. Yet at the same time Strindberg the author resolutely laid his own persona and nightmares out in front of him to dissect and scrutinise under a microscope – even making himself the subject of two novels. It was also during this time that he wrote his insightful letter to Gauguin (see p.142). In all probability, as his biographer Olof Lagercrantz says, here was an experienced dramatist drawing on a troublesome period in his own life to turn it into literature.

He continued to paint, both in the borrowed apartment in Passy and afterwards. For his subject matter he drew on both motifs from the Dalarö summer of 1892 and his more recent impressions of the countryside around the Danube. Stormy seas and a solitary plant on a beach, as well as the theme of the fairy-tale cave were revised. His colour work, whether using palette knife or brushes, became freer, less tightly held together. But he felt pursued by experiences from Dornach: in two of his paintings, *Snow Storm at Sea* 1894 (no.72) and *High Seas* 1894 (no.33), he intensified the drama through the application of dense black colour. In *High Seas*, dissatisfied with the effect of black paint, he went so far as to hold the painting over a burner or a paraffin lamp, causing some of the colour to be charred in places but further heightening the drama. After these paintings his attention seemed to return to alchemy and other scientific experiments and speculations. He did not pick up his paintbrushes again until 1901.

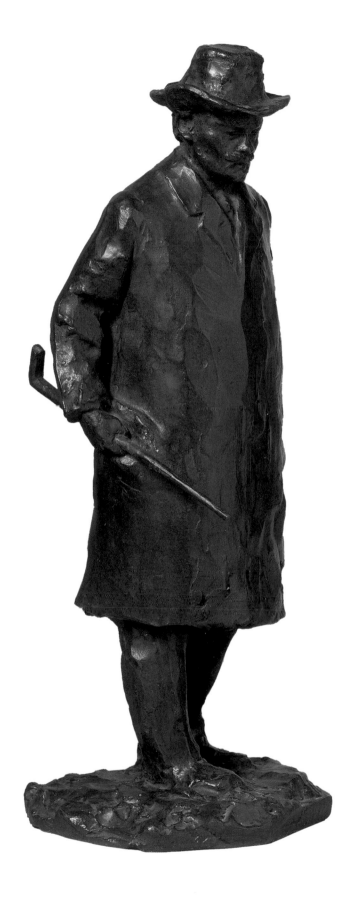

12
Carl Eldh 1873–1954
Strindberg Walking 1904
Bronze, 41 (16 ⅛) high
Moderna Museet, Stockholm.
Gift 1953 from
Moderna Museets Vänner

Just as Strindberg stopped painting his art was beginning to gain recognition back home in Sweden. In the autumn of 1896 a collection of his paintings was put on show in Gothenburg, resulting in some sales, and art critics began at last to take his work seriously. The following year saw the tenth anniversary of the opposition group which had broken with the Royal Art Academy. This was marked by a major exhibition in Stockholm, in which Strindberg took part – ex-catalogue – with *Alpine Landscape* (no.69) and *Wonderland* (no.62). In 1885 he had been close friends with several of the leading figures in the breakaway group, and, even if not an official member of their circle, encouraged them and gave them his moral support. The fact that he was invited to take part in their anniversary exhibition ten years later was a natural acknowledgement of this: his fellow-painters considered him a real painter.

During the winter of 1895 Strindberg became acquainted with Paul Gauguin. Their friendship resulted in a collaboration over the catalogue for the auction in which Gauguin sold everything he possessed in order to finance his second – and last – journey to Tahiti. The well-informed yet rebarbative letter Strindberg wrote to Gauguin shows how distant – even alienated – from contemporary art Strindberg was feeling. He was definitely not affiliated to any particular movement, nor did he see himself as a standard-bearer for something new, which might seem odd considering how revolutionary some of his work actually was. He devoted his life to fighting a sometimes imaginary opposition in the world around him; but when he stood before his easel only the inner truth seemed to matter. Nor can even his essay 'New arts! or The role of chance in artistic production' (see p.131) be seen as a call to take up arms for a new kind of painting. Rather, it was with an air of amusement that he observed what he could accomplish with paint. The end of the essay was written in a tone far from modernistic demands for a better world: 'Art in the future, along with everything else, will disappear! Copy nature though not slavishly; above all, imitate nature's own way of creating!'

Göran Söderström (see p.139) quotes from a letter Strindberg wrote to his artist friend Richard Bergh in the same year (1895): 'Don't ask me where art is heading. One seeks and one looks for something new, only to find, generally, the eternally old, which might blossom anew every twenty-fifth year.' One explanation for this air of meek resignation might be that for Strindberg, a man fighting an ongoing duel with God, the question of art and its execution was merely a part of life's paraphernalia. This view of art certainly put him way ahead of his time: he left behind him all idealism, all academic pontificating, seeing art rather as an existential tool to be employed in the service of life, which – in Strindberg's case – meant trying to capture something of the essence of a transient whole.

Over the next few years he moved to and fro between Paris and the towns of Ystad and Lund in the south of Sweden where he had friends, avoiding Stockholm. It was during this time that he wrote his way out of the *Inferno* crisis and resumed writing for the stage. His first version of *To Damascus* (*Till Damaskus*) written for the theatre in 1898, gives an account of his struggle with a God who had all but converted him, the old blasphemer, to Catholicism. A year later he made a decisive move back to the capital, his native city, where he remained for the last thirteen years of his life, working as a writer, theatre director, painter and photographer. Once again he had access to his beloved Archipelago, and started spending his summers out on Furusund.

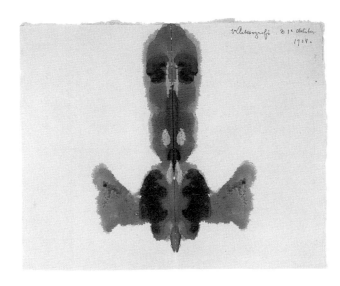

13
Ink Blot Picture. Enclosure to the Occult Diary 1904
Ink on paper
18 × 22 (7 × 8 ¾)
The Royal Library,
National Library of Sweden,
Stockholm

In 1901 he met the young actress Harriet Bosse, proposed and married her. But by the time their daughter Anne-Marie was born a year later their marriage was already on the rocks. The pattern repeated itself: Strindberg disliked being alone, yet was unable to live in a close relationship with anyone else. Once again there was a long-drawn-out divorce, with reconciliations and reunions before a final break. He was to make one more attempt to settle down with a young woman, but never again got beyond the stage of a romantic infatuation.

At the beginning of his marriage to Harriet, a child on the way, Strindberg resumed painting once again. He greeted his newborn daughter with two different versions of *The Child's First Cradle*, variations of the themes from *Wonderland*. Now living more comfortably, he was able to upgrade the size of his canvases. In 1901, on 100 × 70 cm formats, he painted a series of archipelago landscapes, as well as his *Inferno* painting. Of the latter he wrote to Richard Bergh, who had had the painting hanging on his wall for some time: 'View through a Swiss arbour. What you see outside is rain pouring down over little green hills.' Strindberg seemed to regard this painting as a recollected image of a landscape seen long ago: the memories are laid on in layers, Dornach's leafy caves overlapping with the Stockholm Archipelago's gigantic, untamed waves.

The last four years spent painting, 1901–5, were characterised by remembered images from the Archipelago and the Alps. Strindberg also resumed work on such motifs as lighthouses (nos.30, 31) and the White Mare (nos.28, 29). His daily walks out to Djurgården, the royal park close to his home, brought with them a new kind of landscape for him to paint: a cultivated, cultured one, with its avenues, pruned trees, copses and plantations of tobacco flowers and fruit trees in blossom. It was as if a tamed and ageing man finally had averted his gaze from the wildness of the sea and the Alps, to rest it on this cultivated parkscape – like Candide, turning his back on all worldly strife to cultivate his garden. It should not be forgotten that Strindberg was also a passionate gardener, as can be clearly seen in the family snapshots from Gersau (no.81) and his book *Flower Paintings and Animal Sketches* (*Blomstermålningar och Djurstycken*), which he wrote at about the same time. With Strindberg, the ravening titan is never far from the elegiac poet.

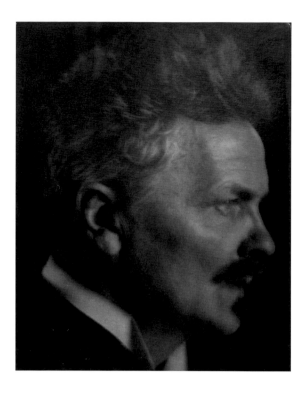

14
Herman Anderson (1856–1909)
August Strindberg 1908
Modern print from original glass
negative in the Royal Library,
Stockholm
12 × 8 (4 ¾ × 3 ⅛)
Strindberg Museum, Stockholm

His painting *The Town* (no.78), which Söderström has dated to 1903, is unique among his work. It measures 95 × 53 cm, its dramatic meeting of sky and sea in shades of grey and black typical of its creator, were it not for for the delicately chiselled silhouette of the city's horizon showing a Renaissance dome in golden hues reminiscent of Venice. Strindberg was no friend of Italy: he had briefly visited the country when he was living in Switzerland in the 1880s, but he had found its mix of luxurious tourism and native poverty disgusting. It is very likely that his inability to speak the language had the same effect of making him feel unsure of himself as it had in England. From his comments on the earlier trip we know he visited the Venice Lido and that he had thus seen the city from a distance. How, one might ask, could a distant image of a destination he had found disagreeable appear with such poignancy two decades later? Could it be that this image of a lagoon enabled him to pay homage to Stockholm, another city on the water, one which he both loved and hated, where he had been so disdained, despite having endowed it with so many knowledgeable and loving descriptions? Seen through this Italian perspective, Stockholm is magically portrayed suspended between the same waters, the same sky he had filled with so much drama throughout his artistic career. *The Town* can be seen as a synthesis of his own life, rooted at home though forever away. It is also a metaphor for Stockholm, the city cowering on a lagoon beneath a stormy, Nordic sky.

When Strindberg stopped painting in 1905 it was not for lack of interest in picture-making: photography merely took over. In the 1890s his photographic experiments went hand in hand with attempts at breaking new ground in scientific areas. Colour photography was in its cradle and Strindberg, undaunted as ever and full of his own theories, threw himself into this field of research. While he was painting in Dornach, he had tried to take photographs of the night sky, the stars, the

moon and the sun without even using a camera. This he had done by placing unexposed film on the window-sill, maintaining that this gave a truer image of the sky than if the film had been passed through a lens. This was how his so-called 'Celestographs' came into being (no.82).

The lens as a distorter of reality was something he would return to in the early years of the 1900s. Together with photographer Herman Anderson, with whom he had begun working, he built the 'Wunderkamera', which enabled him to make life-size photographic portraits with just a single biconvex lens and even without a lens. For Strindberg these photographic portraits held mystic meaning. He told one visitor: 'I don't care about how I look, but I want people to see my soul, and it shows up better in these photographs than in others.'

Scholarship over the last few years has discouraged us from taking August Strindberg's autobiographical works *The Son of a Servant*, *A Fool's Defence*, *Inferno*, *Legends* and *Black Banners*, or his other novels, too much at face value or as a means of finding some inner core to the author's personality. In his biography of 1979 Olof Lagercrantz in particular counselled against reading Strindberg thus. Even in his private life he was highly theatrical, staging his own life and making grandiose appearances in the pages of his books. He was a quite exceptional literary craftsman and one of the most prolific writers Sweden has ever had. But he was also, as we have seen, a practical man capable of recycling and redrafting when his means of making a living were at stake.

What role then did painting, a cumbersome and time-consuming occupation, or his rather absurd ventures into the field of science and gold-making, play in such an exceptional life of words and literature? Was he trying to be a Renaissance man, for whom knowledge had no limits? This is not the impression one gets from reading his work. From beginning to end there is in his writings an ethical pathos verging on despair, and, later, resignation at the world's lack of honesty, justice, honour and love. Zealous though he was in his eagerness to learn, details were for him merely stepping stones. What he strove for was a world in which people were not forever hurting one another. In *A Dream Play* (*Ett Drömspel*, 1902), written towards the end of his life, he summarised this view of the plight of mankind. Over and over again the goddess Indra's daughter, who has come down to earth, repeats compulsively: 'Oh, how pitiful is mankind!' But to see the world as evil implies that we bear within us the opposite picture: of the world as a good place. Indra's daughter exchanges the following words with the lawyer with whom she is about to be united in her earthly existence:

DAUGHTER ... Why do they spit in the face of anyone who wants to help them?

LAWYER They don't know any better!

DAUGHTER Let us enlighten them! You and I together! Will you?

LAWYER They will not accept enlightenment! ...

Oh, if only the gods in heaven would hear our complaint ——

DAUGHTER It shall reach the throne itself! ... Do you know what I see in this mirror? ——

The world set to rights! —— Yes, as it is, it's the wrong way round! ——

LAWYER How did it come to be the wrong way round?

DAUGHTER When the copy was made ...

LAWYER That's it! The copy ... I always did think it was a faulty copy ...

and when I began to recall what the original images were like, I grew dissatisfied with everything ... People called me hard to please and said I had bits of the devil's mirror in my eye, and a whole lot more besides.

(Trans. Michael Robinson, Oxford, 1998)

August Strindberg was a man of many facets: uncompromising scientist, gold-maker and painter, a man who created a world entirely for himself where he was unrestricted and in control, firmly rooted at its centre and capable of dislodging the world. This was how he was able to see the world clearly, and to prevent himself from being pulled down into the moral chaos he found everywhere around him. His non-literary activities gave him a platform and an identity, from which he was able to renew and transform the Swedish language and fundamentally revolutionise art on theatre stages all over the world. From a skerry exposed to the wrath of the elements somewhere in the outer reaches of the Stockholm Archipelago, or from the bottom of a melting-pot where sunlight turned to gold, he was thus able to see the world the right way up. Knowing this, it is over-simplistic to maintain that his scientific monism and his quest for the philosopher's stone were a wild goose chase rather than a dead end. Not for the first time is 'the great creation', the alchemist's goal, a magnificent metaphorical expression for a better world, on which we must set our sights.

Translated by Paul and Veronica Britten Austin

Note
Göran Söderström's book, *Strindberg and his Art* (Stockholm 1972) was the first in-depth analysis of Strindberg as an artist. It was the result of ten years of working with Strindberg exhibitions in Sweden and abroad, combined with a thesis from Stockholm university. The same year he and Torsten Måtte Schmidt published *Strindberg's Paintings* (Malmö 1972), with Söderström's catalogue comprising 120 paintings of which he believes no more than ten have been destroyed or lost. A few paintings have been found since the catalogue was published, but its chronology, drawn up by Söderström, is still valid. The book also includes contributions by other authors, together with Schmidt's account of how Strindberg's work has been received, from his first exhibition in 1892 up to 1970. The most complete account of Strindberg's work as a photographer is Per Hemmingsson's *Strindberg, the photographer* (Stockholm 1963).

The nomadic nature of Strindberg's life complicates research. Over the course of his lifetime he compiled three libraries; when two of these were put up for sale the catalogue was incomplete. His last collection of books was made after he had finally decided to settle in Stockholm, and is preserved in the Strindberg Museum. In two invaluable volumes, *Strindberg and Books I* and *II* (Uppsala 1977 and 1990), Hans Lindström traces Strindberg's reading over the years from shopping lists, correspondence and library receipts, as well as by studying the extant library and the notations and underlinings in every single book.

On reading Strindberg's essay 'New arts!' (see p.131), one might at least expect to find references to the elder Pliny or Leonardo da Vinci, but this is not the case. In his *Blue Books*, begun long after he wrote the essay, they are often referred to in a scientific rather than an artistic context. In the Strindberg Museum library there is a volume with a selection of Leonardo's writings translated into French by Sâr Peladan, published in Paris in 1907. The volume contains Peladan's dedication to Strindberg, and has a few marks by Strindberg concerning scientific enquiries. It is understandable that Strindberg had difficulty keeping his books in order considering that he spent two decades moving from one rented room or apartment to the next. What is remarkable is that he read as much as he did while writing and accumulating his encyclopedic knowledge. Exactly how important his scientific studies and speculations were to him can be found in the contents of the so-called 'Green Bag' that he always had to hand. Here he kept articles on scientific subjects, both his own and other people's, the instruments he needed for his experiments, his Celestographs, a mass of relics from passing interests, and notes on scraps of paper which he would eventually use when writing his *Blue Books*. The contents of the Green Bag have been preserved and indexed at the Royal Library in Stockholm.

Plates

Many of Strindberg's novels are loosely based on his own life. *The Growth of the Soul* (Part I of *The Son of a Servant*) provides an insight into his first experiments with painting. He describes the protagonist, his own alter ego, Johan:

who had already, with the greatest calm, composed a song with a guitar-accompaniment, thought it not impossible for him to paint, and he borrowed an easel, colours, and a paint-brush. Then he went home and shut himself up in his room. From an illustrated paper he copied a picture of a ruined castle. When he saw the clear blue of the sky he felt sentimental, and when he had conjured up green bushes and grass he felt unspeakably happy as though he had eaten hashish.

(*The Growth of the Soul*, 1887, trans. Claud Field, New York 1914)

Ruin, executed in 1894, is based on this first attempt at painting, Strindberg's own rendition of the ruined Scottish castle. His description of the process of painting indicates the satisfaction that he derived from the painterly process. Perhaps this might be compared to the pleasure that he experienced in his later alchemical experiments, transforming base matter (be it iron or paint) into another, higher, form – his so-called gold, or a finished painting.

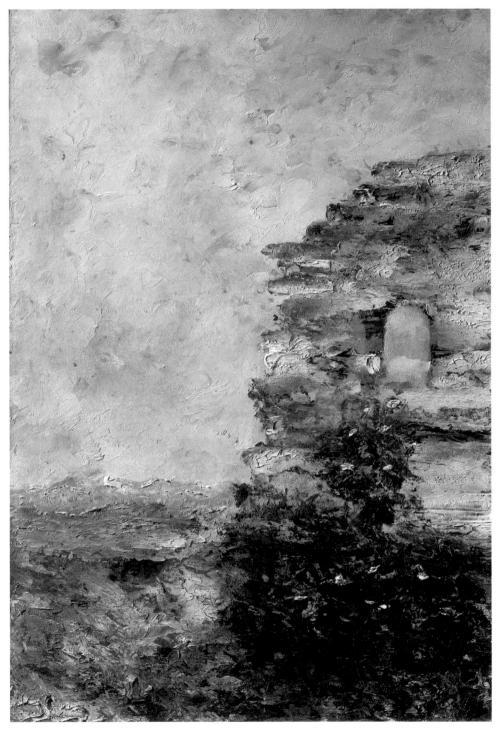

15
Ruin 1894
Oil on panel, 39 × 26.3 (15 ³/₈ × 10 ³/₈)
Private collection

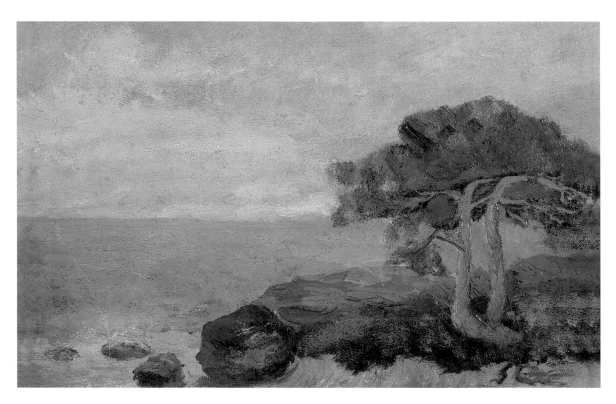

16
Beach, Kymmendö I 1873
Oil on cardboard, 16 × 26 (6 ¼ × 10 ¼)
Private collection

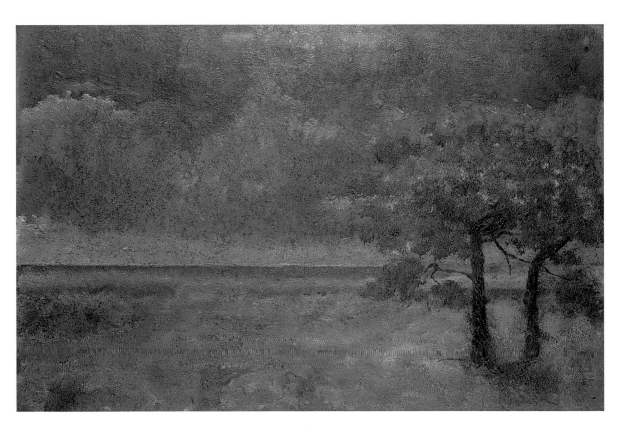

17
Beach, Kymmendö II 1873
Oil on wood, 17.5 × 24.5 (6$^7/_8$ × 9$^5/_8$)
Örebro Konsthall, Sweden

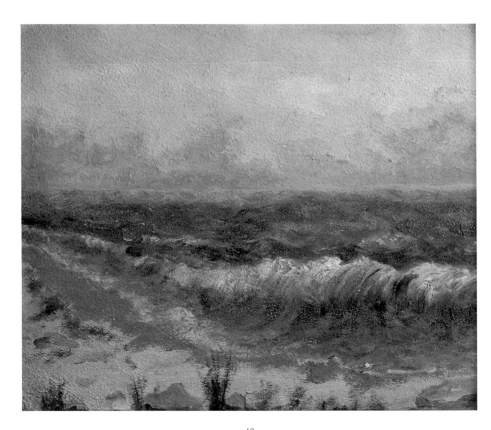

18
Beach, Sandhamn 1873
Oil on cardboard, 15.5 × 18.5 (6 ¹/₈ × 7 ¹/₄)
Nordiska Museet, Stockholm

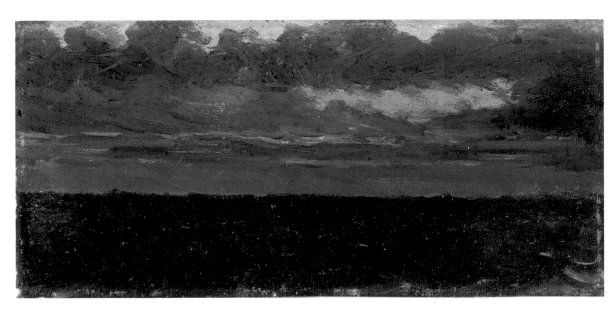

19
Storm after Sunset at Sea 1873
Oil on canvas 12 × 25 (4 ³/₄ × 9 ⁷/₈)
Private collection

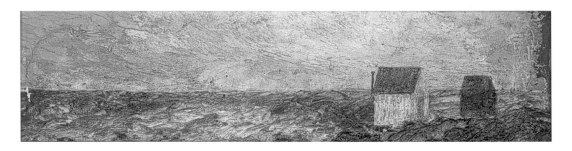

20
Lighthouse 1892
Oil on cardboard, 6.5 × 18 (2 ¹/₂ × 7)
The Royal Library, National Library of Sweden, Stockholm

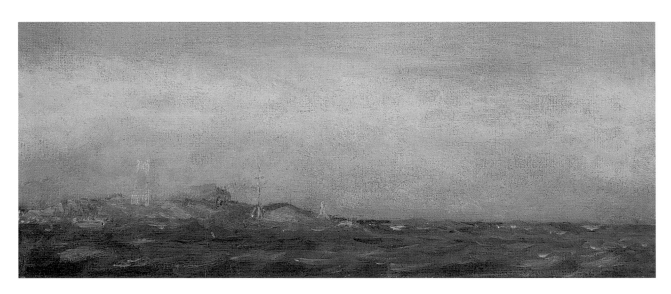

21
Skerry with Lighthouse 1873
Oil on canvas, 12.5 × 31 (4 ⁷/₈ × 12 ¹/₈)
Private collection

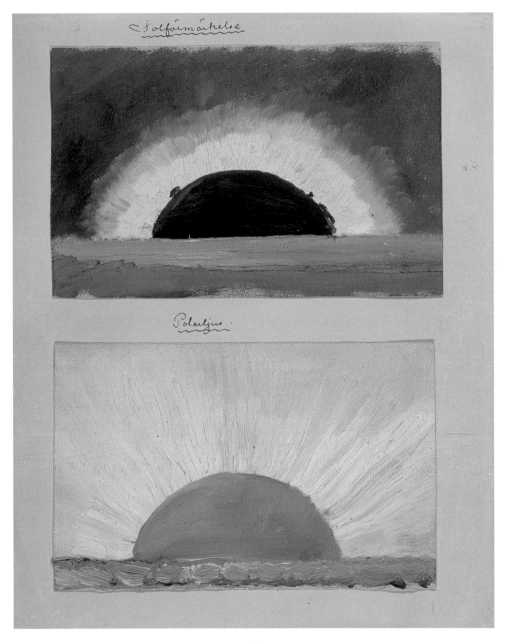

22
Eclipse and *Polar Light* 1891
Oil on cardboard, 11 × 17 (4 ¾ × 6 ⅝) each
21 × 27 (8 ¼ × 10 ⅝) mounted together
The Royal Library, National Library of Sweden, Stockholm

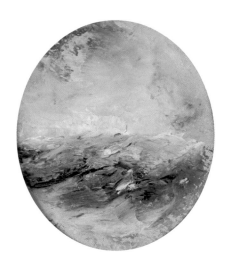

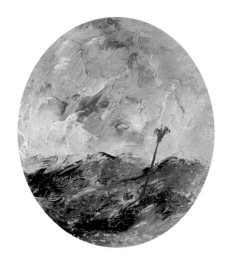

23
The Wave I 1892
Oil on cardboard, 8 × 7 (3 ⅛ × 2 ¾)
Private collection

24
Broom Buoy I 1892
Oil on cardboard, 8.5 × 7.5 (3 ⅜ × 3)
Amells Stockholm – London

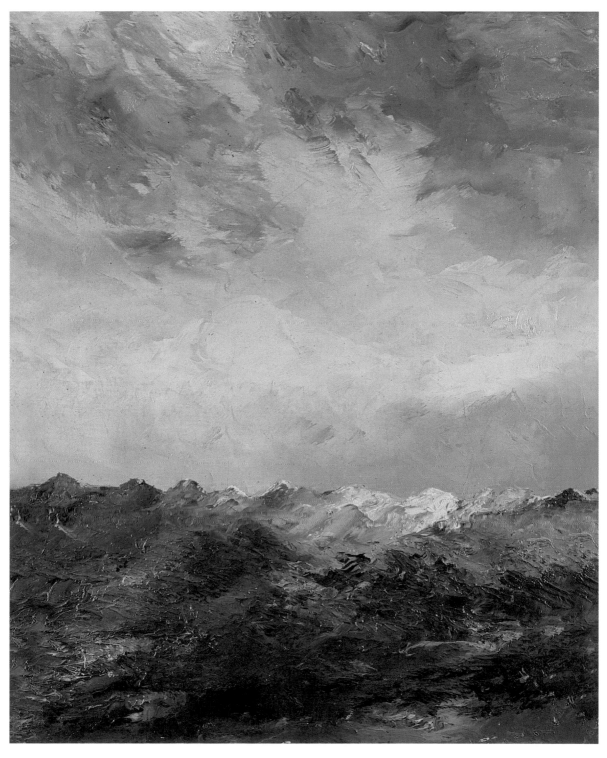

25
Mysingen 1892
Oil on cardboard, 45 × 36.5 (17 ¾ × 14 ⅜)
Bonniers Portrait Collection, Nedre Manilla, Stockholm

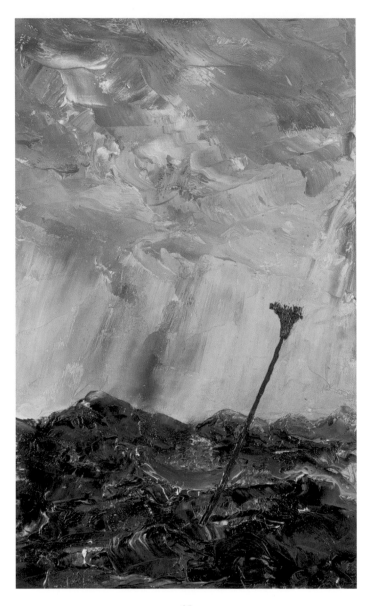

26
Stormy Sea. Broom Buoy 1892
Oil on cardboard, 31 × 19.5 (12 ⅛ × 7 ⅝)
Nationalmuseum, Stockholm

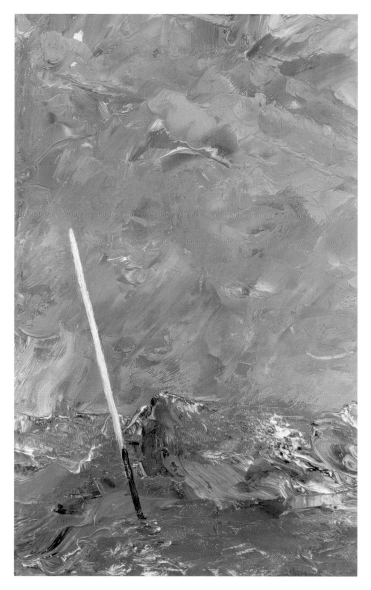

27
Stormy Sea. Buoy without Top Mark 1892
Oil on cardboard, 31 × 19 (12 ⅛ × 7 ½)
Nationalmuseum, Stockholm

Strindberg spent the summer of 1892 in Dalarö, an island in the Stockholm Archipelago, and here took up painting again after a break of almost twenty years. Many of the paintings from this period feature a single man-made object, such as a buoy or navigational mark, at the mercy of the elements. The White Mare seamark is the subject of several literary and painterly representations. Strindberg claimed that he was the first to paint symbolic landscapes, and it is possible to see these images as metaphors for his own efforts to push the boundaries of art within a conservative society. While he never flinched from writing stories and plays that challenged public mores, he nevertheless suffered greatly when called to task for this. He faced blasphemy and indecency charges over some of these publications, and although always acquitted he was deeply wounded by these actions.

Written in 1889–90, Strindberg's novel *By the Open Sea* tells the story of a sensitive and intelligent individual who takes a post as fisheries inspector in an outlying island. Failing to find support for his activities among the populace, who ridicule his attempts to make them adopt a more sustainable fishing practice, he seeks solace in the surrounding landscape. *The White Mare* here reflects his solemn mood:

A dark cliff came into view on the headland of the last island. It was coal-black … and as he drew near it he became depressed … The gleaming walls … squeezed and crushed him and when he had climbed up by the clefts a tall sea-mark post with a cask on top, painted white, rose up before him. This example of man's handiwork, out here, where no man could be seen; this reminder of gallows, shipwreck and coal; this crude contrast between the unblended colourless colours black and white of violent infertile nature, lacking organic life … without the link of vegetation between primitive nature and human activity, seemed shocking, disturbing and brutal.

(*By the Open Sea*, trans. Mary Sandbach, London 1987)

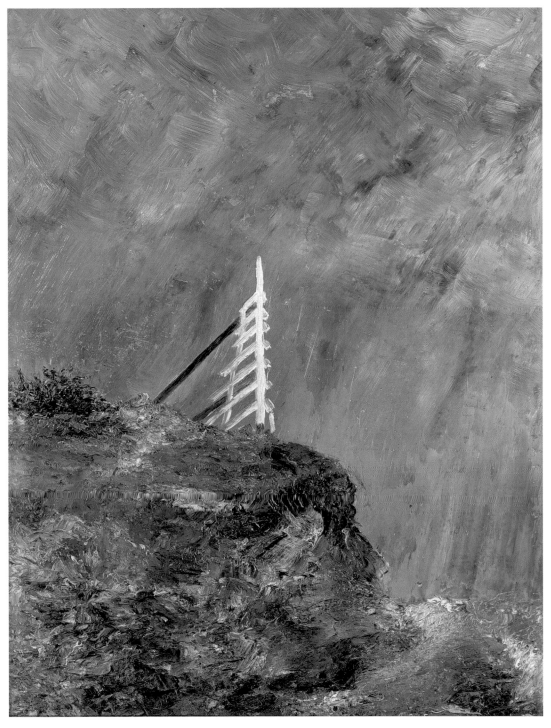

28
The White Mare II 1892
Oil on cardboard 60 × 47 (23 $^5/_8$ × 18 $^1/_2$)
Nationalmuseum, Stockholm

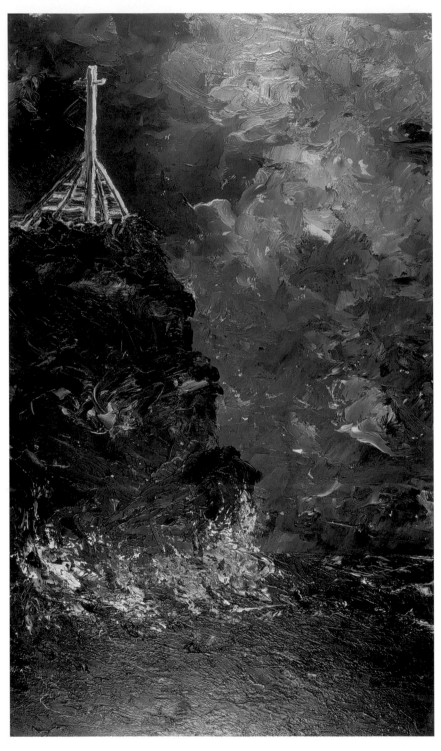

29
The White Mare IV 1901
Oil on wood, 51 × 30 (20 × 11⁷/₈)
Örebro Konsthall, Sweden

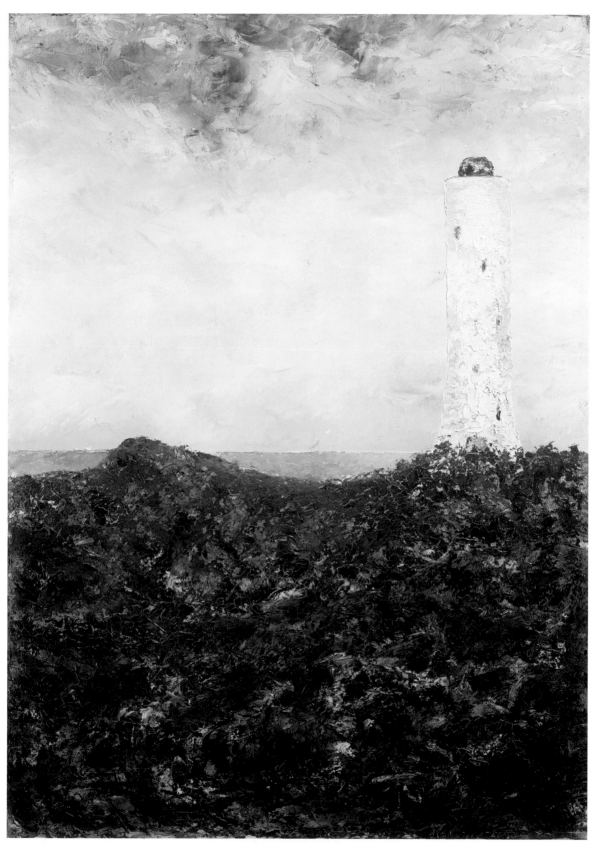

30
The Lighthouse II, Stockholm 1901
Oil on canvas, 100 × 71 (39 ³/₈ × 28)
Private collection

For Strindberg the image of a lighthouse was loaded with meaning. In his *Occult Diary*, written in 1900, he describes a moment of pure happiness when confronted with the view of a lighthouse whilst on a sea voyage. Paradoxically, a lighthouse signals danger first and foremost, yet also, by virtue of its presence, salvation too. In Strindberg's mind this lighthouse signified a moment of orientation, of finding one's bearings. However, as so often with Strindberg, there is another way to view the situation. In the closing chapter of *The People of Hemsö* (1887) the protagonist, Carlsson, and his stepson, Flod, have capsized their boat and are attempting to reach the nearby church over a stretch of frozen sea. On this occasion the sight of the lighthouse offers scant consolation:

'This is the end of us!' Gusten suddenly cried. He stopped for a brief second and pointed to a light flashing from behind a rock to the south-east. 'The beacon is lit – that means that the ice has broken up and the water is clear!' ... They were surrounded by total darkness and the pale, blurred light flickering from the lighthouse suddenly went out, after having – like an auxiliary sun – helped them to find their way for a few brief minutes.

(*The People of Hemsö*, trans. Arvid Paulson, New York 1965)

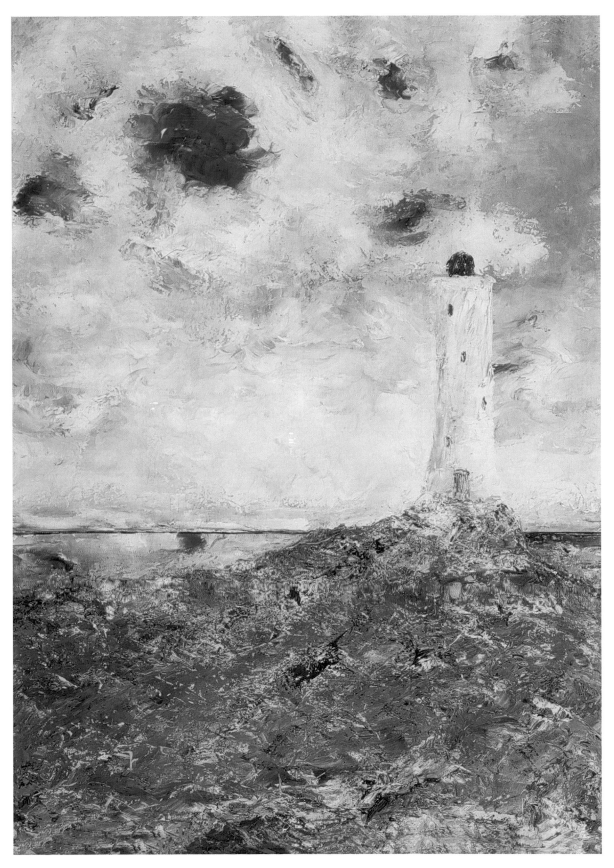

31
The Lighthouse III 1901
Oil on canvas, 99 × 69 (39 × 27⅛)
Uppsala University Collection

Applying paint direct from the tube using a palette knife, Strindberg created extraordinary seascapes where the elements seem to be boiling with fury. The legend of the Flying Dutchman, captain of a ghostly ship condemned to sail through the storms off the Cape of Good Hope for eternity, was a source of inspiration for his poem, published in 1904, an excerpt of which is produced below. It is unlikely that Strindberg actually set out to paint the subject, but the multi-layered paint provided a perfect breeding ground for his imagination and he believed that the ghostly ship could be discerned within the image.

The Dutchman
First Song

The first year I aimless roamed
the waters' desert, fled enticing shores,
at times saw a Christmas candle, a midsummer
bonfire beckon from lands unknown

yet never a flower I saw nor a tree
ploughed field nor verdant meads;
glanced only down into darkest depths
where algae swayed on mile-long beds

There was my summer, my consolation;
saw up to the sun when equinox brought spring,
when moving stars announced the autumn:
when winter came nursed my wounds, my scars

The seventh year – so was my fatal doom –
I turned my prow to the closest shore
and the curse hurled by Rome itself
landed my ship and her crew on dry sand.

(From the collection of poems *Playing with Words and Minor Art*, published in Swedish 1904; trans. Paul Britten Austin.)

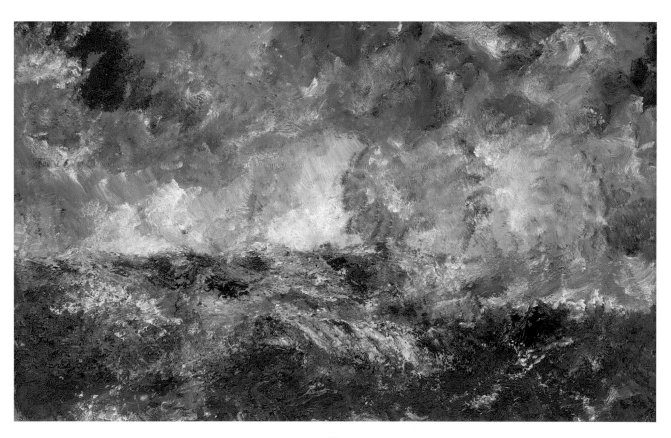

32
Storm in the Archipelago (The Flying Dutchman) 1892
Oil on cardboard, 62 × 98 (24 1/2 × 38 5/8)
Statens Museum for Kunst, Copenhagen

This work was painted in Paris in 1894 in preparation for an exhibition that Strindberg had been promised by Willy Gretor, a wealthy Danish artist who had provided him with studio and living space at his apartment in the Parisian suburb of Passy. Strindberg seems to have grown in confidence and believed that his painting might be a way to overcome the financial difficulties he was facing. However, it became apparent that Gretor was a con man suspected of dealing in forgeries and, fearful of being involved in another scandal, Strindberg was quick to break off all contact with him.

Per Hedström has noted that the technique used in this painting is something of a departure for Strindberg. Further developing his technique of heavy impasto of unmixed colours applied with the palette knife, here Strindberg has begun to mix other materials into the paint to achieve a rougher texture and some areas appear to have been burnt in order to achieve a deeper degree of blackness. Strindberg's experimental techniques and engagement with the materiality of paint were quite unprecedented. Interesting comparisons may be drawn here with later developments in painting such as those of Anselm Kiefer, who mixed straw and sand into his landscapes, and Alberto Burri, whose interest in metamorphosis led him to burn, melt and char his paintings in the 1950s.

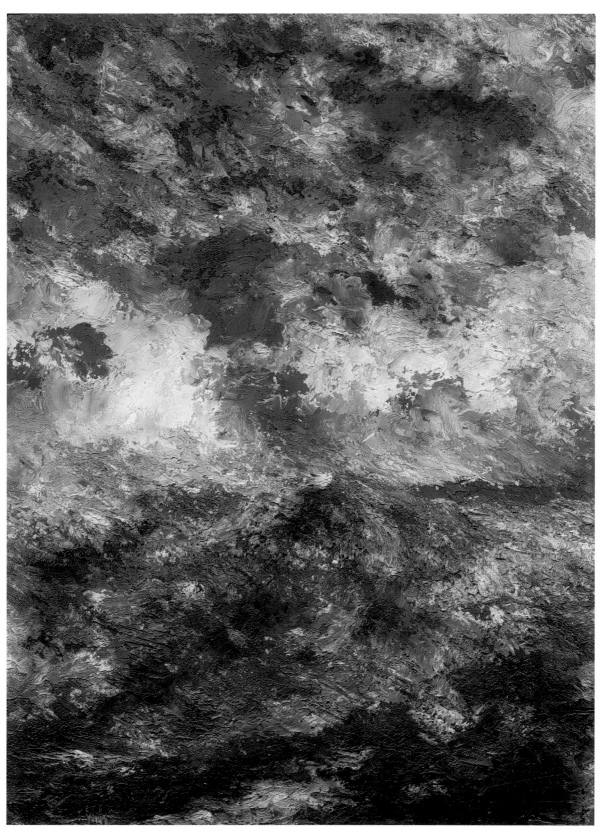

33
High Seas 1894
Oil on cardboard, 96 × 68 (37 ¾ × 26 ¾)
Folkhem Konstsamling

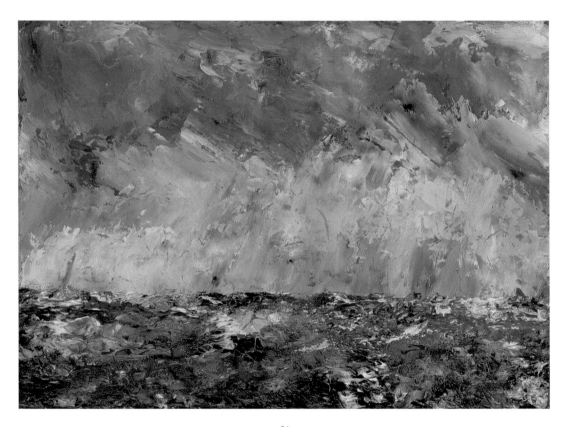

34
Blizzard 1892
Oil on wood, 24 × 33 (9 3/8 × 13)
Prins Eugens Waldemarsudde, Stockholm

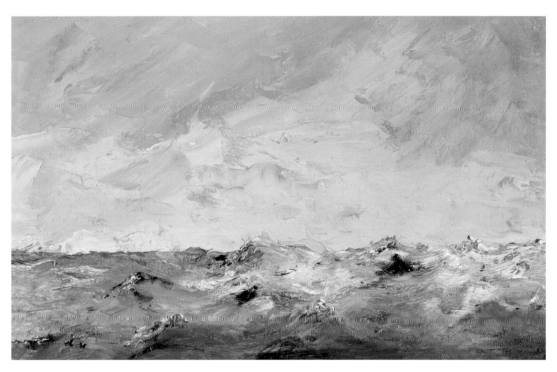

35
Little Water, Dalarö 1892
Oil on cardboard, 22 × 33 (8 ¾ × 13)
Nationalmuseum, Stockholm

Strindberg was staying in Dornach, Austria on the estate of Frida Uhl's grandparents when this work was painted. Although many of the works from this period feature the surrounding landscape around the Danube, he continued to paint seascapes such as this from memory. Strindberg once again calls upon the viewer's imagination to access the images within his paintings. The subject is all but lost in the heavy impasto of the paint, yet Strindberg describes the scene in minute detail in his letter to Leopold Littmansson of 31 July 1894:

A man in a billowing raincoat is standing on a cliff which is being washed by the ocean waves; far out on the horizon, the three white-painted, unrigged masts of a stranded bark.

On closer inspection one sees that the man on the cliff has a slouch hat like Vodan [Buddha]; that the crests of the waves resemble monsters, the clouds demons, and in the middle of the sky is an excellent likeness of Rembrandt. The three masts with their cross-bars look like Golgotha, or three crosses on graves, and could be a 'Trimurti', but this is a matter of taste.

(Ibid.)

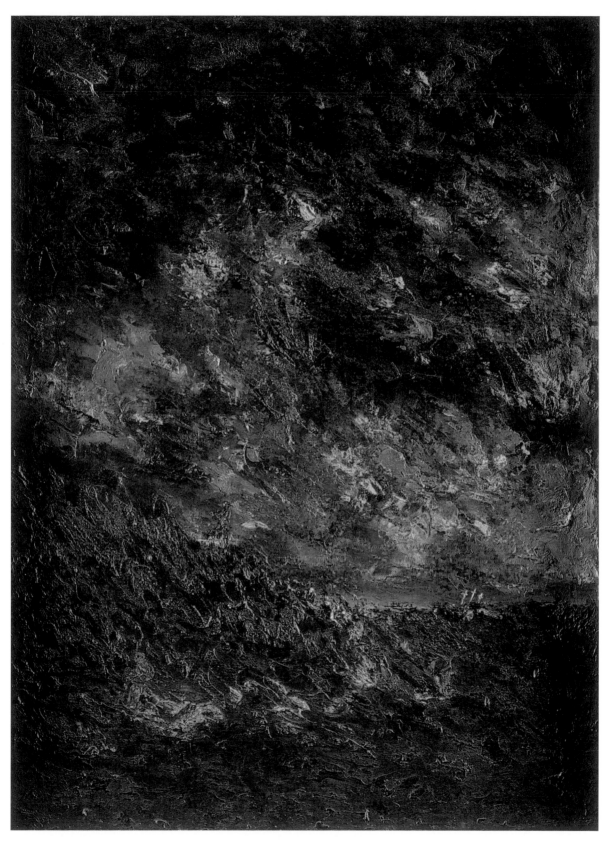

36
Golgotha, Dornach 1894
Oil on canvas, 91 × 65 (35 7/8 × 25 1/2)
Private collection

It is not known what caused Strindberg to make this painting, which not only stands out as unique in his own oeuvre, but also seems to have no parallels in the art of his contemporaries. Composed of two segments of canvas, it appears to be the amalgam of sections of two separate paintings – one tempestuous seascape and another more tranquil landscape. Highly aware of his own propensity to mood swings, it may be an attempt on Strindberg's part to acknowledge the extremes within his own character. By his own admission he could simultaneously appear sociable and calm and yet be boiling with rage or anguish under the surface. Whatever the motive, it was undoubtedly a radical way of approaching painting.

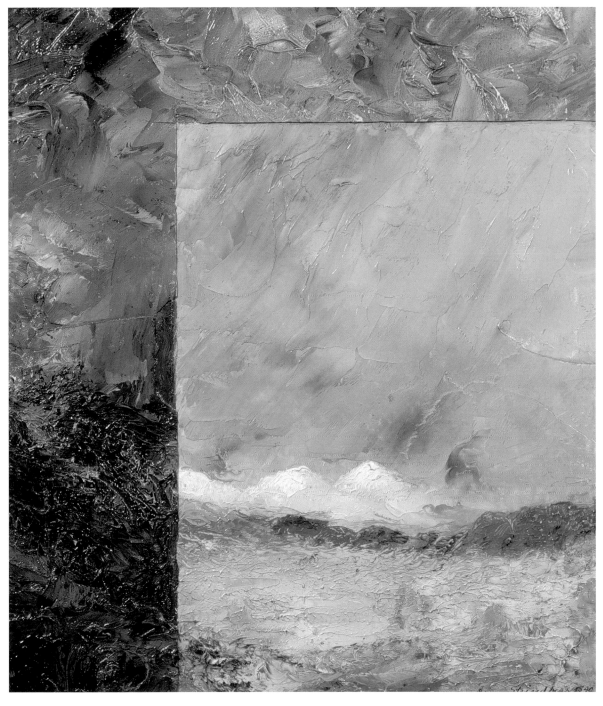

37
Double Picture 1892
Oil on cardboard, collage, 40 × 34 (15 ³/₄ × 13 ³/₈)
Private collection

Strindberg's study of the natural sciences, coupled with his fertile imagination and interest in eastern religions, led him to conclude that 'everything exists in everything'. For Strindberg the cycle of life was such that minerals might one day be present in the bodies of animals, plants or human beings. He noted similarities between the markings on a crab shell and the shapes formed by crystals on glass; and far from attributing this to coincidence, he saw this as the 'memory' of a substance's former existence being recreated in its current form. When he rose from his bed he saw classical sculptures in the shapes formed by his head resting on the pillow, and in cliff forms he here sees his own profile, which can be seen by viewing the painting upside down.

In a similar composition, *Cliff III* (no.39) the division between sea and sky is almost imperceptible. The idea of another version of the world, the perfect reflection of earth on the other side of heaven, continued to fascinate Strindberg:

… when I see the sea and sky merge in the blue air, making the horizon invisible, it seems to me to be a single substance, all water, or all air; they are reflected in each other. And is it from the higher waters that clouds, rain, dew, frost flowers come?

(Letter to Torsten Hedlund, 18 July 1896)

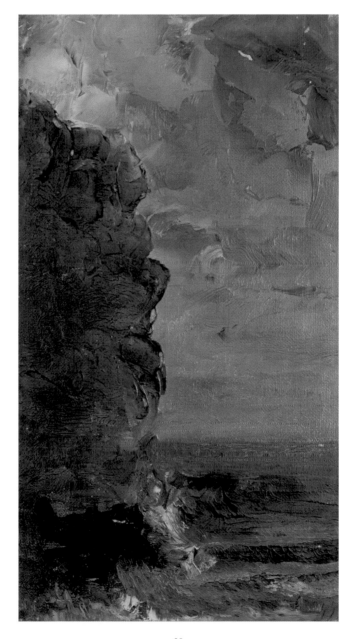

38
Cliff I 1902
Oil on canvas, mounted on cardboard, 20 × 11 (7³/₄ × 4³/₈)
Nordiska Museet, Stockholm

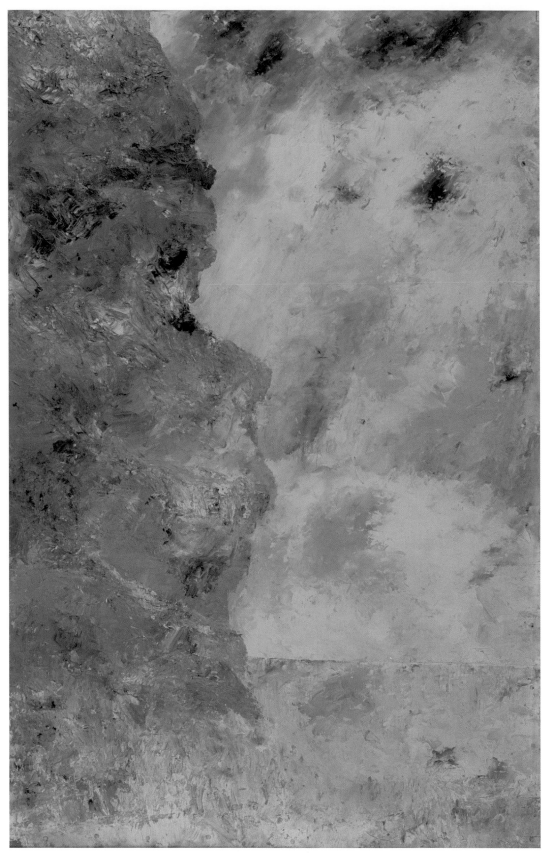

39
Cliff III 1902
Oil on cardboard, 96 × 62 (27 ⅛ × 24 ½)
Nordiska Museet, Stockholm

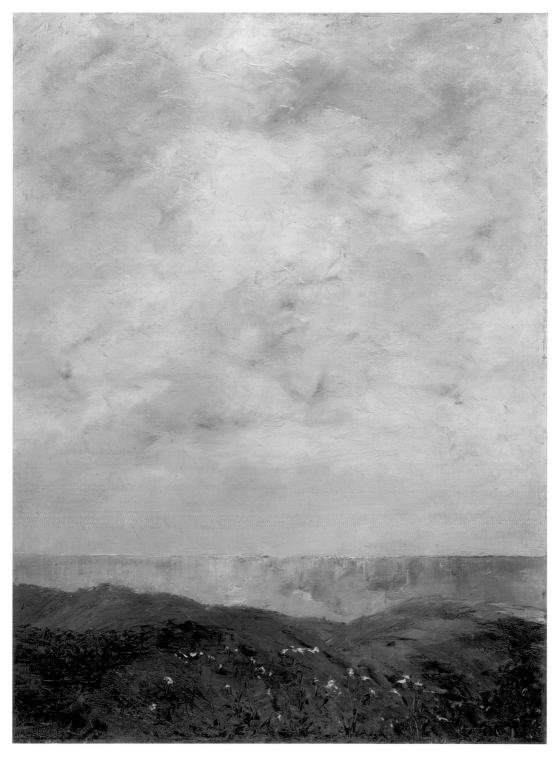

40
Coastal Landscape II 1903
Oil on canvas, 76 × 55 (30 × 21⅝)
Nationalmuseum, Stockholm

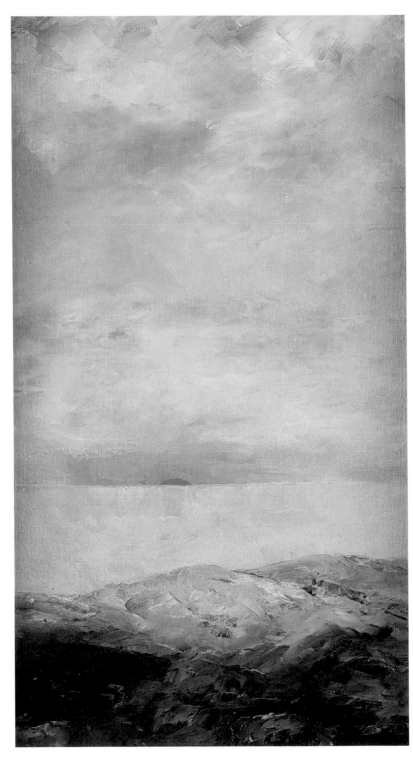

41
Sunset over the Sea 1903
Oil on canvas, 95 × 53 (37 3/8 × 20 7/8)
Private collection

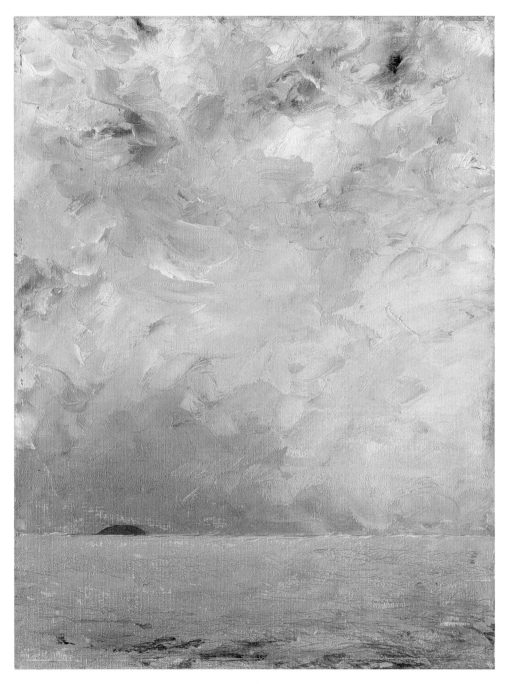

42
Sunset 1903
Oil on cardboard, 40 × 29 (15 ¾ × 11 ⅜)
Private collection

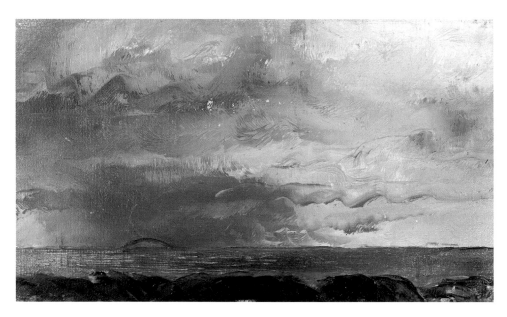

43
Sunset 1902
Oil on canvas, 13 × 21 (5 ¹/₈ × 8 ¹/₄)
Private collection

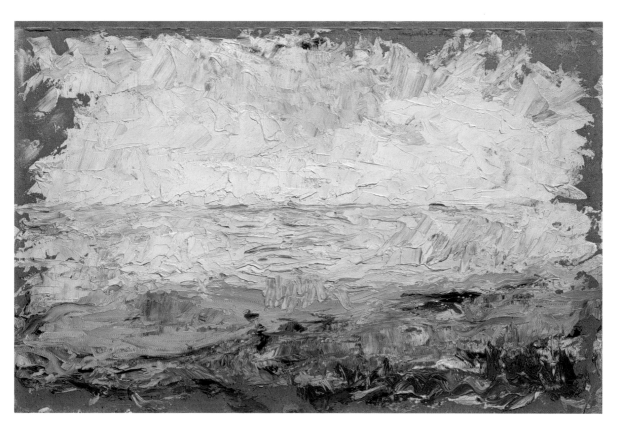

44
Shore Scene 1894
Oil on cardboard, 26 × 39 (10 $\frac{1}{4}$ × 15 $\frac{3}{8}$)
Strindberg Museum, Stockholm

When Strindberg took up painting again in 1892 his technique was more assured and he quickly established a repertoire of motifs to which he returned repeatedly. Among the most beautiful of his paintings are those of solitary flowers on the seashore. In the same period the artist was also painting dark and turbulent images of stormy seas; but these delicate paintings portray Strindberg in a quite different mood, capturing the tranquil beauty of the landscape around Dalarö in the soft light of a Nordic summer.

Although the beaches are always deserted, there is still a sense of human presence, reminiscent of the compositions of Caspar David Friedrich, whose images of solitary figures in a landscape were known to Strindberg. The solitary flowers may be interpreted as symbolic self-portraits, standing in for the artist who, despite his great fame and position at the centre of artistic circles, believed himself to be isolated.

Strindberg was an enthusiastic botanist, and the finesse with which he depicts the flowers is in marked contrast to the looser handling of the surrounding landscape. If these solitary specimens really are self-portraits, then there is perhaps an element of self-critique in his choice of subject matter. One work depicts an attractive but nevertheless spiky thistle (no.48); in another painting (see p.19) the flower is replaced by a poisonous toadstool; and here he chooses purple loosestrife which, despite its beauty, is a pernicious weed with a reputation for destroying the natural balance of the coastal environments in which it thrives.

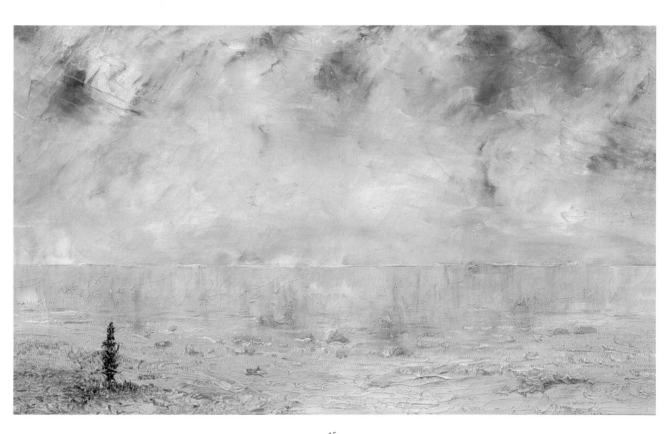

45
Purple Loosestrife 1892
Oil on canvas, 35 × 56 (13 ³/₄ × 22)
Private collection

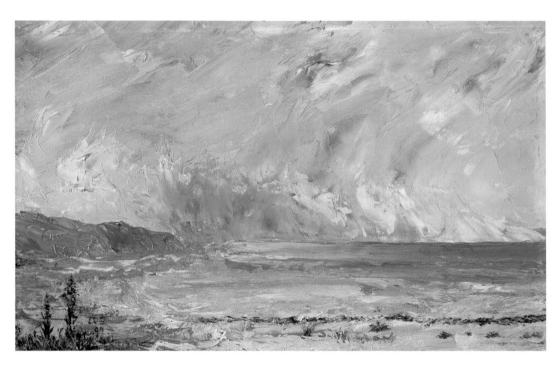

46
Flower on a Beach 1892
Oil on zinc, 20 × 32 (7 3/4 × 12 5/8)
Manassas Foundation

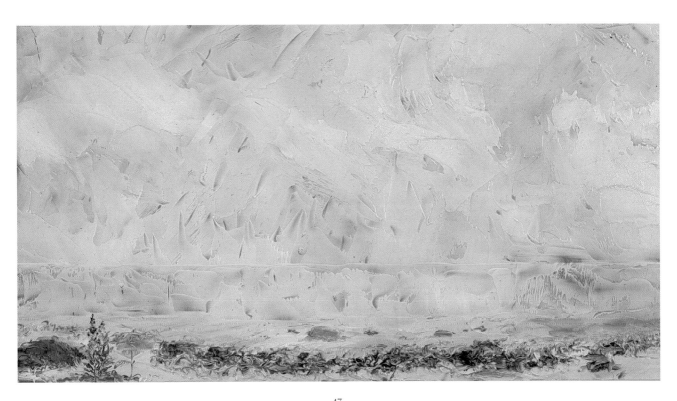

47
Flower on the Shore, Dalarö 1892
Oil on zinc, 24.7 × 43.5 (9 ³/₄ × 17 ¹/₈)
Malmö Konstmuseum / Malmö Artmuseum, Sweden

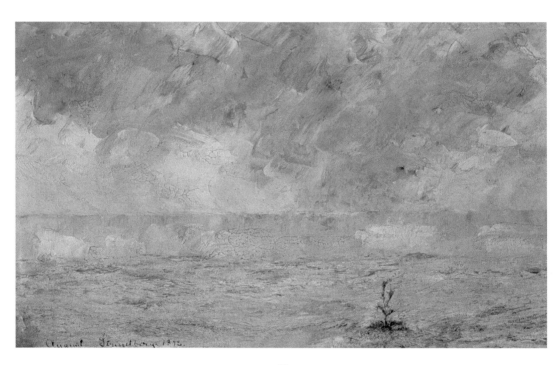

48
The Solitary Thistle 1892
Oil on cardboard, 19 × 30 (7 ½ × 11 ⁷/₈)
Private collection

49
Beach, Summer Night 1892
Oil on zinc, 20 × 32 (7 ¾ × 12 ⅝)
Private collection

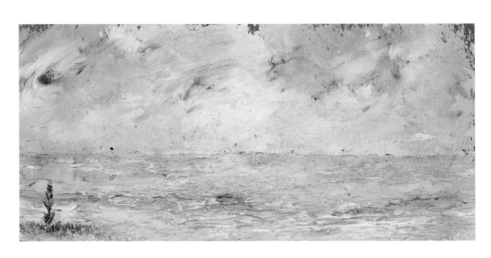

50
Torch Flower No 1 1892
Oil on cardboard, 9 × 18.5 (3.5 × 7¼)
Private collection

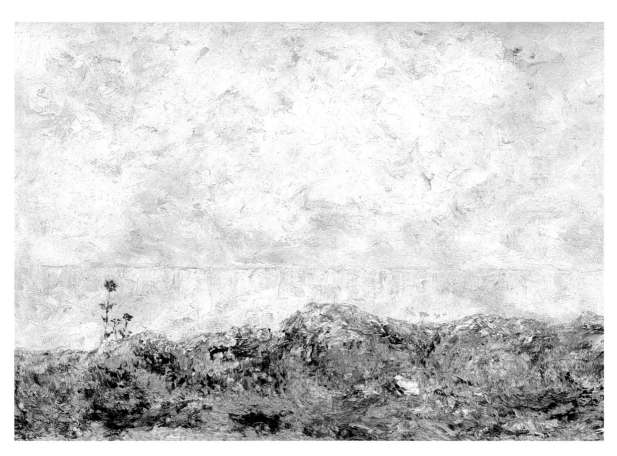

51

Flower on the Beach, Paris-Passy 1894

Oil on cardboard, 29 × 42 (11 3/8 × 16 1/2)

Private collection

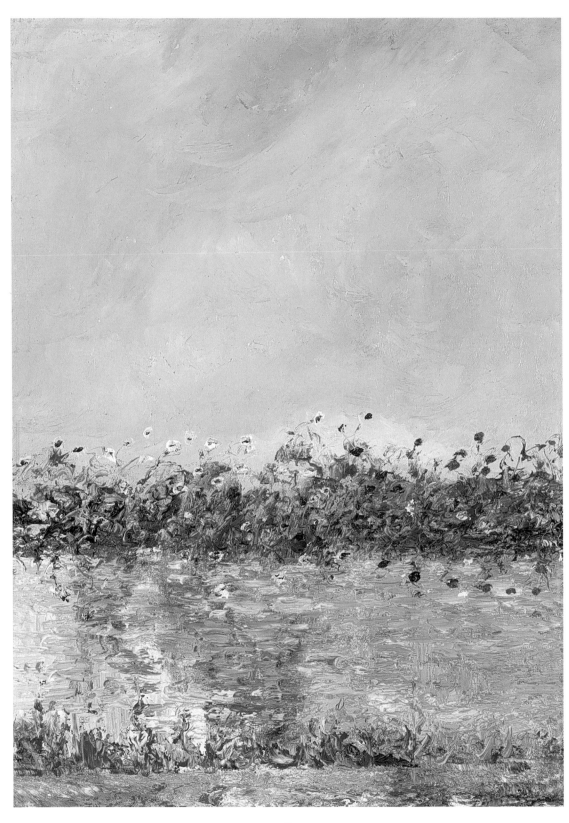

52
Flowering Wall c.1901
Oil on canvas, 52 × 36 (20 ¹/₂ × 14 ¹/₈)
Private collection

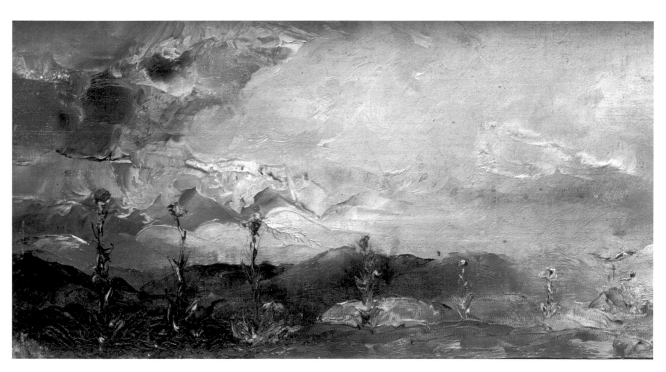

53
Landscape with Tobacco Flowers 1902
Oil on canvas, 12 × 23 (4 ³/₄ × 9)
Nordiska Museet, Stockholm

Seen against the backdrop of Strindberg's beloved Archipelago, the lonely tree might be taken as a symbol for the artist. Socially Strindberg undoubtedly enjoyed the company of fellow artists and writers, but he often seemed keen to distance himself from them artistically. The following passage from *By the Open Sea*, also using the motif of a solitary tree on the shore, might allude to his reasons for keeping this distance:

The single rowan stood on a few square feet of greensward, so solitary yet, in the absence of competitors, so unusually strong, as if it was better able to defy storm, salt and cold than the scramble of envious equals for the bits of earth.

(*By the Open Sea*, trans. Mary Sandbach, London 1987)

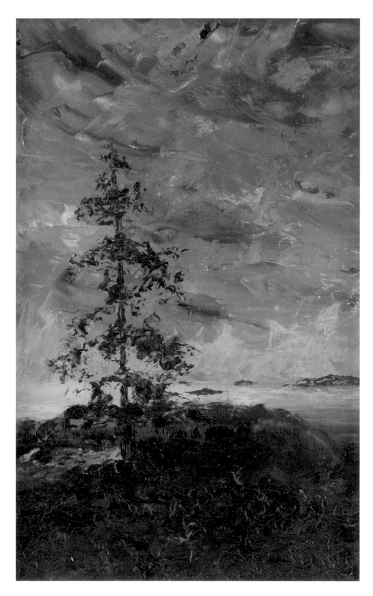

54
The Lonely One 1892
Oil on cardboard, 30 × 19 (11⅞ × 7½)
Private collection

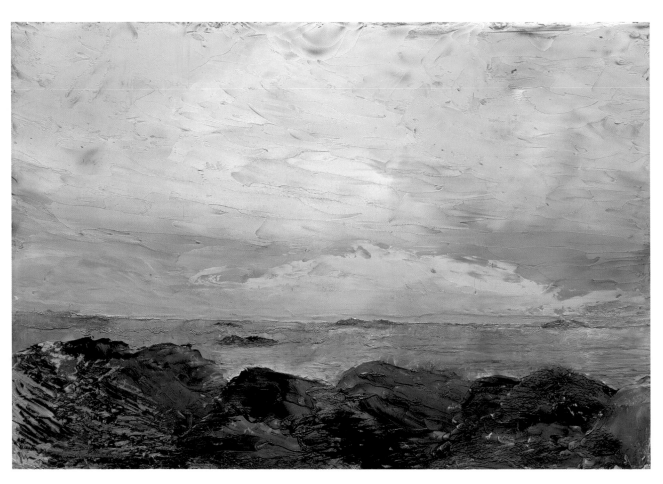

55
In the Archipelago (Recto) 1892
Oil on zinc, 43 × 62 (17 × 24 1/2)
Private collection

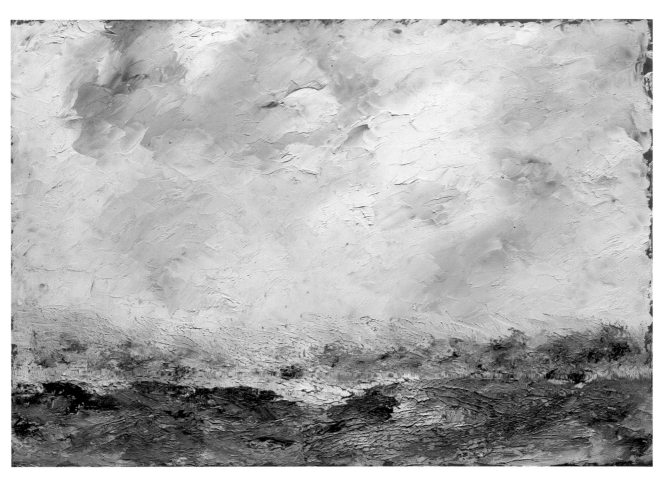

56
Sea-Scape (Verso) 1892
Oil on zinc, 43 × 62 (17 × 24¹/₂)
Private collection

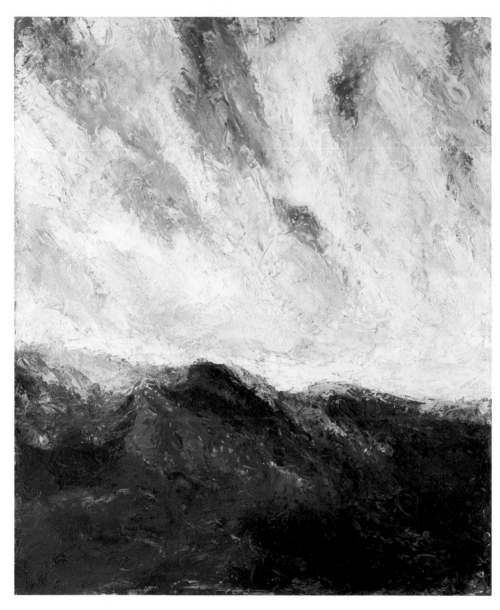

57
Waves c.1893
Oil on board, 47.4 × 39.3 (18 ⅝ × 15 ½)
Private collection

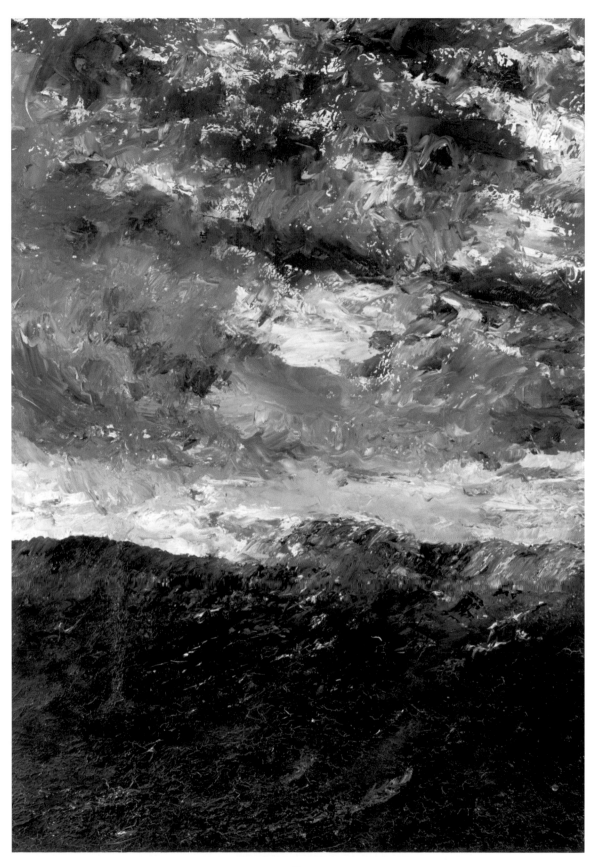

The Wave VI 1901–2
[Verso, *Wave VIII*, not reproduced]
Oil on canvas, 100 × 70 (39 3/8 × 27 1/2)
Nordiska Museet, Stockholm

Of all the motifs that Strindberg adopted, the image of a wave breaking in open sea is perhaps the most often repeated. Sometimes the breaker seems to be sandwiched between sheer walls of dark green sea and sky, with just a chink of light on the horizon. In the opening passages of *By the Open Sea* the protagonist, Axel Borg, is steering his boat across a stormy, dark ocean when he becomes aware of

a dark eminence against the horizon ... sight of this breaker affected the inspector as the sight of the coffin in which his dismembered body will lie affects a man condemned to death, and in the moment of apprehension he experienced a mortal dread both of cold and suffocation. This paralysed his muscles but, on the other hand, it roused all the hidden powers of his spirit.

(*By the Open Sea*, trans. Mary Sandbach, London 1987)

Other images are less structured and Strindberg seems to be interested in the play of light on the waves. In an earlier passage a more benign wave greets the travellers:

The sun was now down on the horizon and the waves were breaking, purplish black at their base, with walls of a deep green, and crests at their highest point the shining green of grass. The spray splashed and spluttered, rosy-red in the sunlight, the colour of pink champagne, while the boat and its crew were down in the dusk. Then, up on the ridge of the wave again, the four faces would be lit up for a moment, only to be extinguished immediately.

(Ibid.)

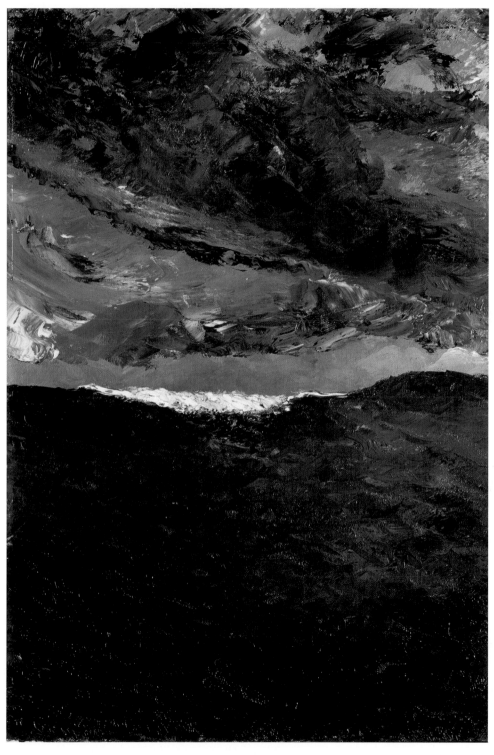

59
The Wave VII 1901
Oil on canvas, 57 × 36 (22 ³/₈ × 14 ¹/₈)
Musée d'Orsay, Paris

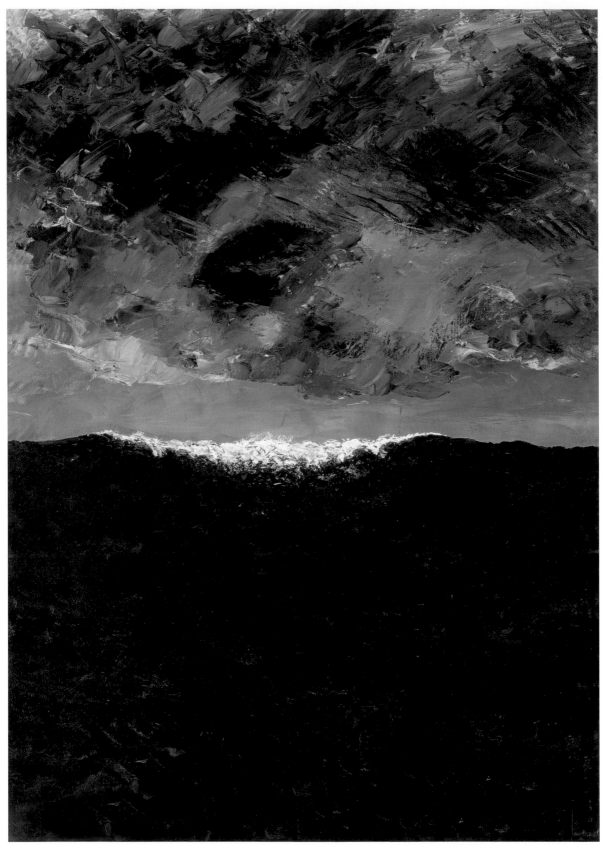

60
The Wave V 1901
Oil on canvas, 101 × 70 (39 ¾ × 27 ½)
Private collection

61
The Wave IX c.1901
Oil on canvas, 21 × 13 (8 ¼ × 5 ⅛)
Private collection

This painting was one of a number of works that Strindberg sent to Leopold Littmansson in July 1894, describing them as:

a new (that's to say, old) kind of art which I've invented and call L'art fortuite [the Art of Chance] … Each picture is, so to speak, double-bottomed, with an exoteric aspect that everyone can make out, with a little effort, and an esoteric one for the painter and the chosen few … All the pictures are painted using only a knife and unmixed colours, whose combination has been half left to chance, like the motif as a whole.

(Letter to Leopold Littmansson, 31 July 1894)

Strindberg goes on to describe the creation of this work in the essay 'New arts!' (see p.131), a seminal essay which prefigures the automatic techniques expounded by the Surrealists twenty years later. In his letter to Littmansson he goes on to describe the exoteric and esoteric meanings as follows:

Exot. *A dense forest interior; in the middle, an Exot. Hole opens out into an idealised landscape where sunshine of every colour streams in. In the foreground, rocks with stagnant water in which mallow-worts are reflected.*

Esot. *The Wonderland; the battle of light against darkness. Or the opening of the realm of Ormuzd and the exodus of the liberated souls to the land of the sun; under it the flowers (they aren't mallows) decay in 'gnothi seauton' before the muddy water in which the sky is reflected.*

(Ibid.)

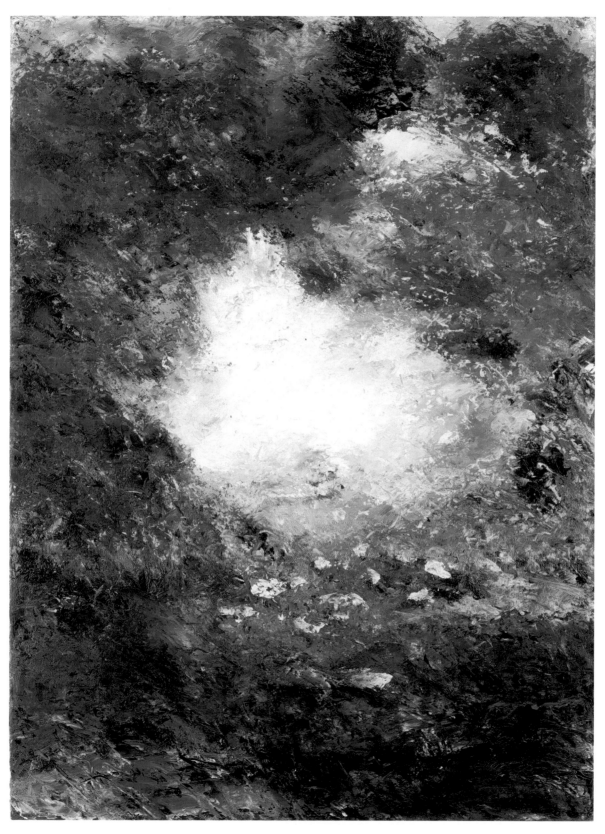

62
Wonderland 1894
Oil on cardboard, 72.5 × 52 (28 ⅝ × 20 ½)
Nationalmuseum, Stockholm

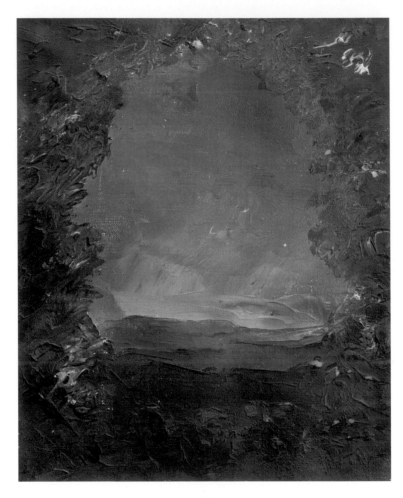

63
The Cave (Inferno II) 1902
Oil on canvas, mounted on cardboard, 21 × 17 (8 ¹/₄ × 6 ⁵/₈)
Nordiska Museet, Stockholm

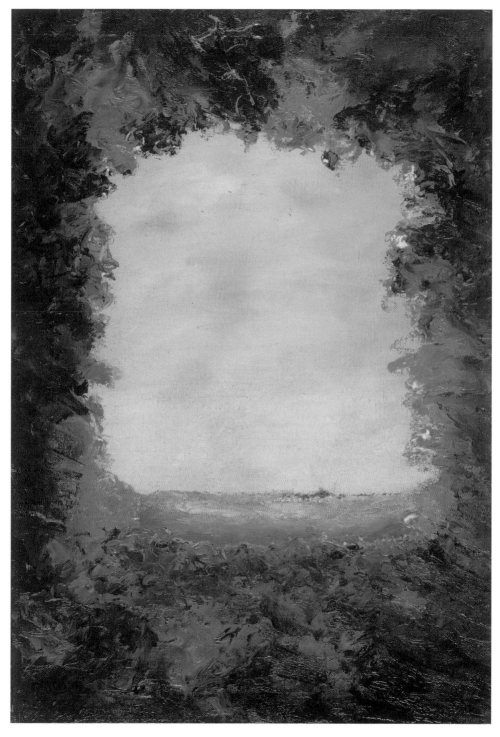

64
The Yellow Autumn Painting 1901
Oil on canvas, 54 × 35 (21¼ × 13¾)
Manassas Foundation

In his last period of activity as a painter Strindberg produced a series of works which seem to be based on the original composition of *Wonderland* 1894, looking out as if from a wood or cave into a clearing or towards the sea. The mood of these paintings varies considerably and Strindberg's titles betray a certain ambivalence in his attitude towards this motif. On the one hand the cave might be seen as a symbol for the security of the maternal embrace (see no.66), but in other renditions such as this there is a sense of claustrophobia and entrapment, perhaps another manifestation of Strindberg's complex relationship with the opposite sex. In stark contrast to the enchanted, mystical world conjured up in *Wonderland*, painted at a time of relative contentment, the view in *Inferno* seems to be into a rain-sodden landscape, perhaps a 'vale of tears'. Although Strindberg had by now recovered from the intense period of psychoses (which he called his 'inferno period') which he suffered in the mid- to late 1890s, this painting is an attempt to capture that mood on canvas.

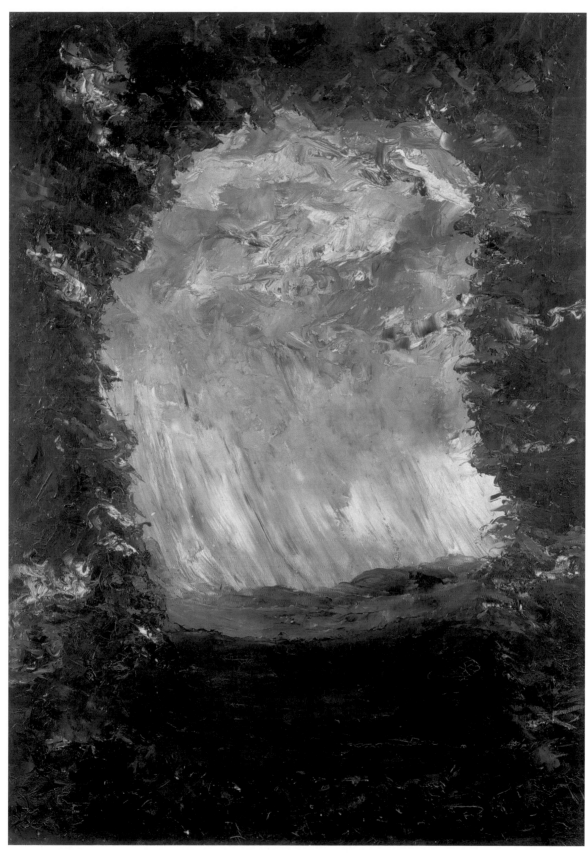

65
Inferno 1901
Oil on canvas, 100 × 70 (39 ³/₈ × 27 ¹/₂)
Private collection

In September 1901 Strindberg sent a poetic letter addressed 'To my child! (The unborn little one)', which was probably meant as much for the mother, Strindberg's estranged third wife Harriet Bosse, as for his unborn daughter Anne-Marie. Despite the problems that existed in the marriage, Strindberg wanted his daughter to know that she was the product of love, conceived in the idyllic setting of a cottage by the sea at Hornbaek in Denmark. Here rendered in warm tones, the cave motif is womb-like and nurturing:

And you, child of the South and the North, were carried in the light green beech-woods by the blue sea!

And your beautiful mother rocked you on blue billows in the sea that washes three kingdoms — and in the evenings, when the sun was going down — she sat in the garden and turned her face to the sun to give you light to drink.

Child of the sea and the sun, you slept your first slumber in a little red ivy-clad house, in a white room, where no word of hatred was ever even whispered, and an impure thought was unknown!

(Letter to Anne-Marie Strindberg, 4 September 1901)

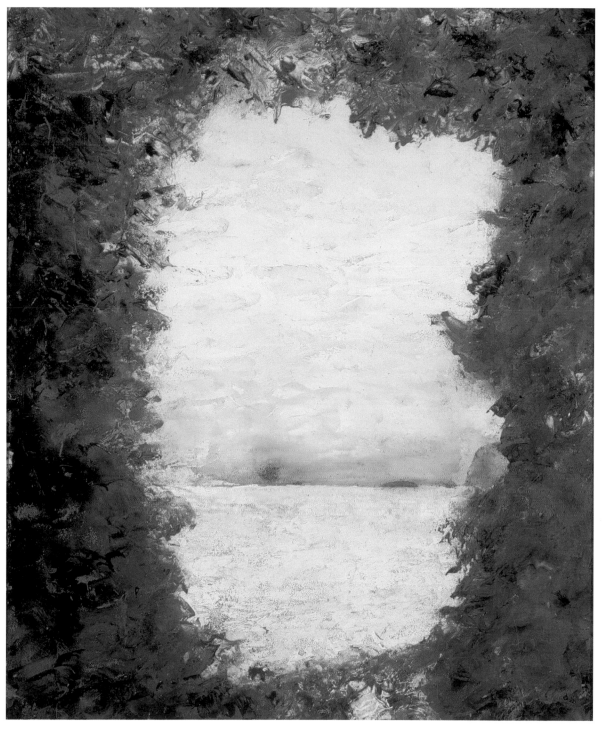

66
The Child's First Cradle 1901
Oil on paper, 45 × 38 (17³/₄ × 15)
Private collection

In the summer of 1894 Strindberg and Frida, who was pregnant with their daughter Kerstin, stayed at her family's estate on the River Danube at Dornach, Austria. Although he was ultimately to fall out with his new relatives and his young wife, this seems to have been a period of relative contentment in Strindberg's life. He took new inspiration from the landscape around the Danube. The symbol of the flood, with its implication of future redemption, was undoubtedly in his mind when he later came to analyse the painting. In a letter, written on a return visit to Austria in 1896, he wrote:

My impressions of Austria? Well, I'm more at home here than in Sweden, and feel as though I was born here, for I've planted trees and brought forth a child here. Besides, all the rabble of the world has passed this way along the Danube so I feel really at home in my role as tramp … Here 'everything is in flux' and is always new, every tenth minute.

(Letter to Count Fredrik Wrangel, 22 September 1896)

A year after this painting was executed, whilst undergoing the series of psychoses that he later called his 'inferno period', Strindberg wrote to Torsten Hedlund:

In Genesis it says that God created a space and separated the higher waters from the lower and called the space heaven … There were now two waters, one above heaven and one below.

(Letter to Torsten Hedlund, 18 July 1896)

The Danube in Flood seems to embody this idea, with both water and sky taking on the colours of the earth that separates them.

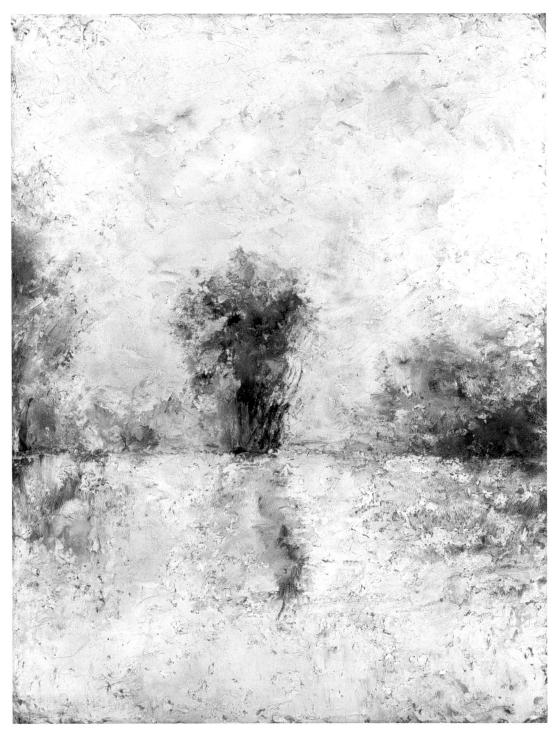

67
The Danube in Flood 1894
Oil on panel, 44 × 33 (17³/₈ × 13)
Private collection

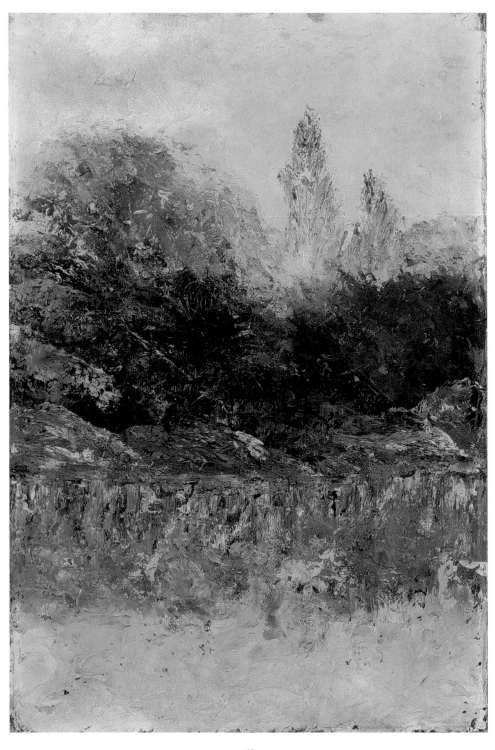

68
The Verdant Island II 1894
Oil on cardboard, 39 × 25 (15 3/8 × 9 7/8)
Strindberg Museum, Stockholm

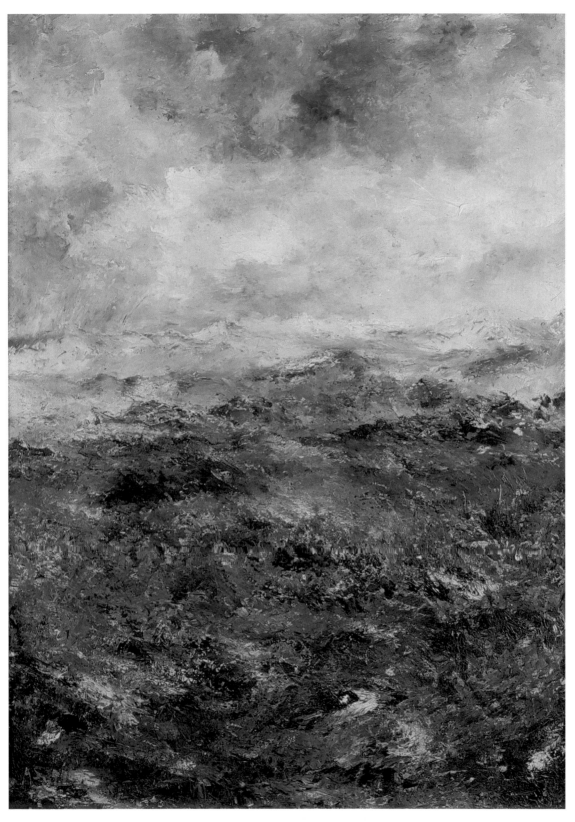

69
Alpine Landscape I 1894
Oil on cardboard, 72 × 51 (28 ³/₈ × 20)
Private collection

The dedication on the reverse of this painting indicates that Strindberg gave this painting to Frida Uhl, soon to be his second wife, as an engagement present:

To Miss Frida Uhl from the artist (the Symbolist August Strindberg). The painting depicts the sea (bottom right), clouds (top), a cliff (on the left), a juniper bush (top left), and symbolises: a Night of Jealousy

Strindberg and Uhl met in Berlin when Strindberg was the centre of a group of artists and writers who socialised at a wine bar known as *Zum schwarzen Ferkel* (the Black Piglet). The group who associated there lived a bohemian, promiscuous lifestyle and inevitably there were times when jealousy became an issue. His friend Edvard Munch dealt with the subject in his painting *Jealousy* of 1895, a psychological drama based on the figures of the Polish novelist and playwright Stanislaw Przybyszweski, Munch himself and Dagny Juel, a Norwegian writer who had affairs with both Strindberg and Munch before marrying Przybyszweski.

Strindberg's attempt to treat the subject of jealousy is much more oblique, ferociously applying paint to express the torment that jealousy inspired. It us unclear whether he had a particular incident in mind when he wrote his dedication but it is certain that his relationship with Uhl was under strain from an early stage.

Strindberg's writings earned him a reputation for misogyny and his volume of short stories, *Married*, is harshly critical of women's liberation. Paradoxically, he was always drawn to strong, emancipated career women. Although just twenty years old, Uhl had already established a career in journalism and she enthusiastically set about trying to nurture Strindberg's career. Strindberg admitted his affair with Juel, which took place after he became secretly engaged to Uhl, but his fiancée seems to have been willing to grant him his freedom. In contrast, his letters to her express his concern that her attempts to court the interest of publishers and theatre directors on his behalf sometimes led her to behave in a manner that he considered inappropriate for a married woman.

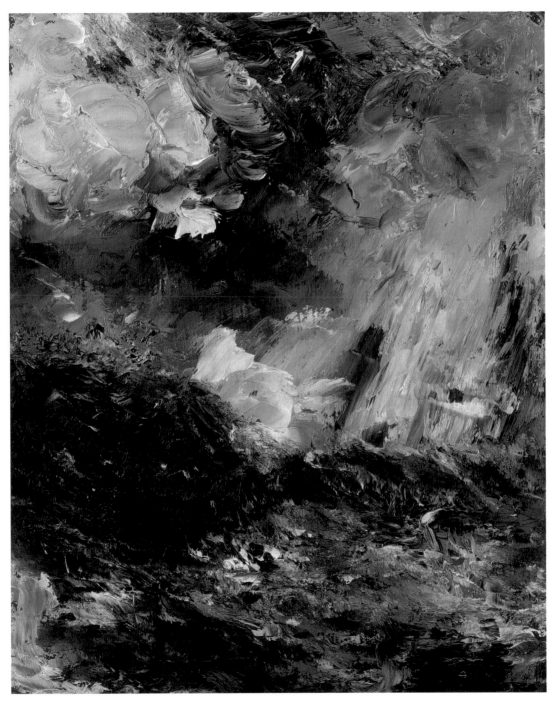

70
Night of Jealousy 1893
Oil on cardboard, 41 × 32 (16 1/8 × 12 5/8)
Strindberg Museum, Stockholm

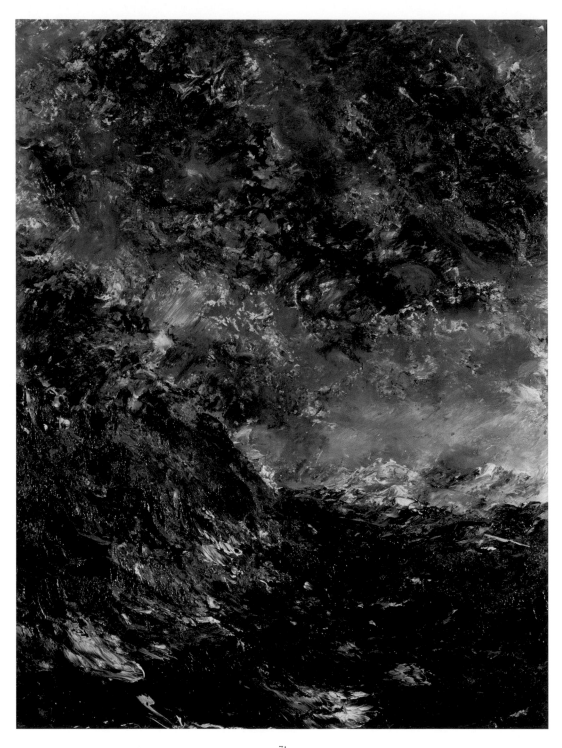

71
Seascape with Rock 1894
Oil on wood, 40 × 30 (15 ¾ × 11 ⅞)
Musée d'Orsay, Paris; Don de Karl Otto Bonnier et de ses enfants par l'intermédiaire des Amis du Musée d'Orsay, 2002

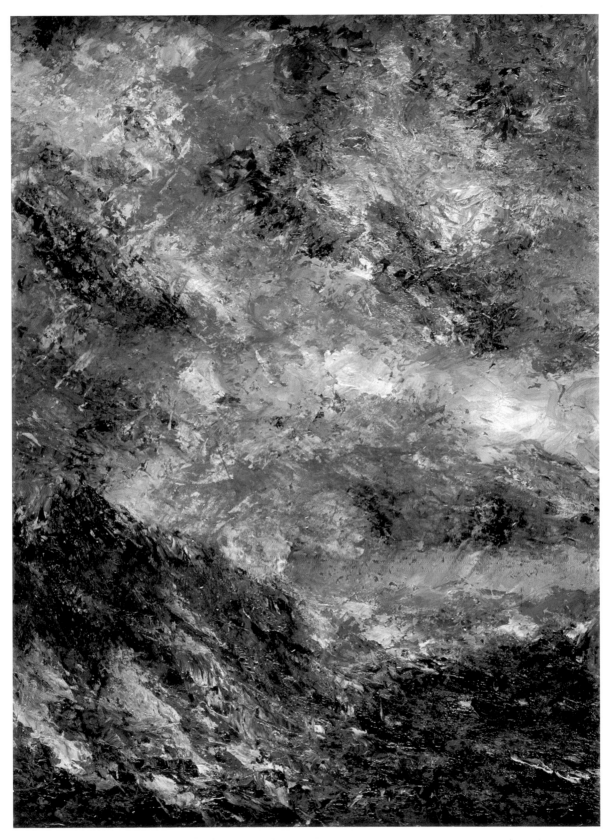

72
Snow Storm at Sea 1894
Oil on cardboard, 66 × 47 (26 × 18 ½)
Nordiska Museet, Stockholm

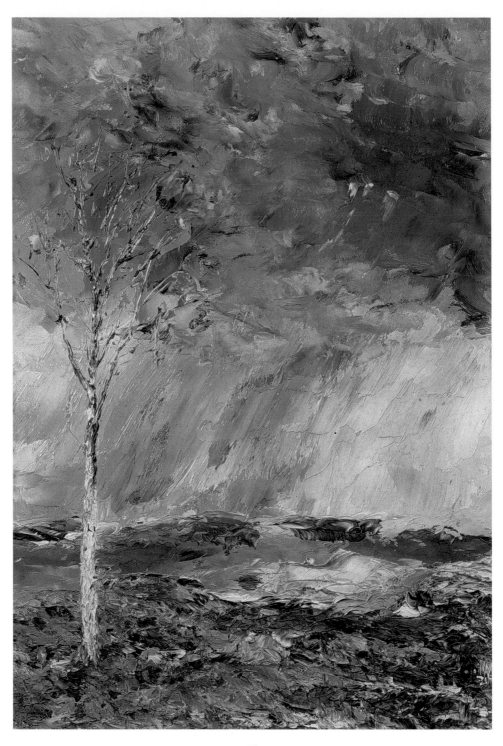

73
The Birch Tree I 1901–2
Oil on cardboard, 33 × 23 (13 × 9)
Private collection

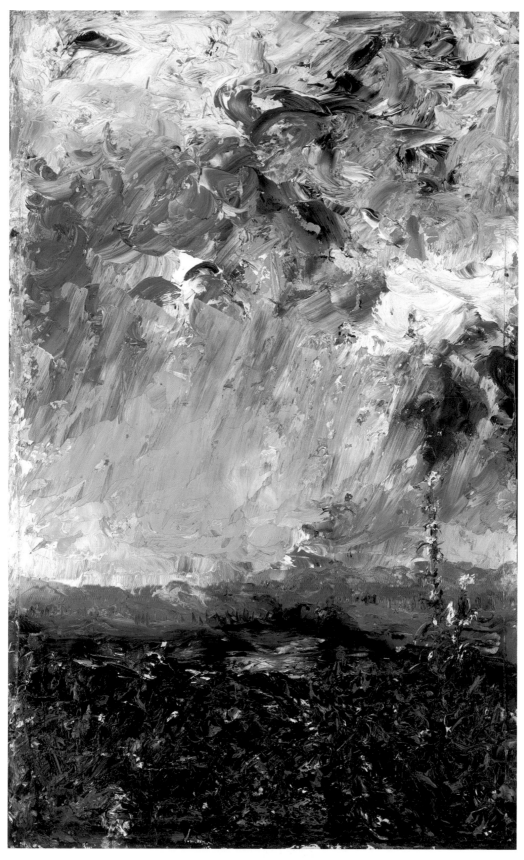

74
Flower of the Moor 1901–2
Oil on paper, 50 × 30 (18⅝ × 11⅞)
Private collection

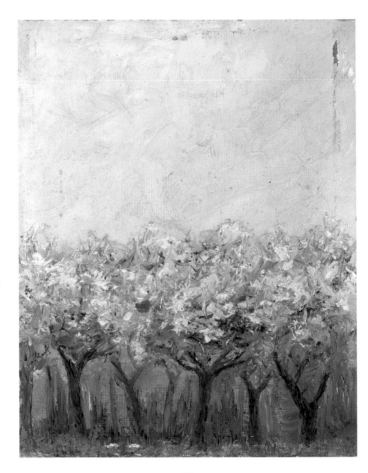

75
Apple Trees in Blossom 1903
Oil on cardboard, 17 × 13 (6⅝ × 5⅛)
Private collection

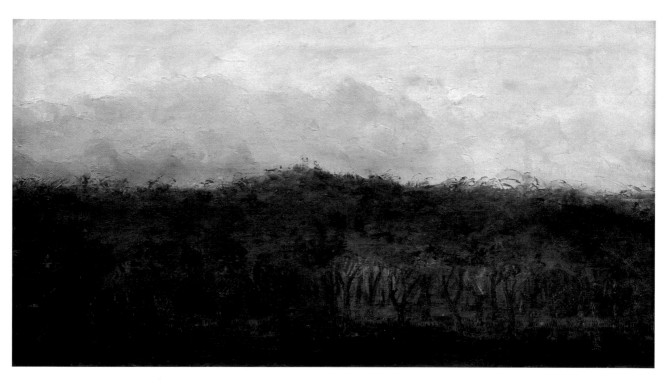

76
Rosendal Gardens 1903
Oil on canvas, 54 × 93 (21 $\frac{1}{4}$ × 36 $\frac{5}{8}$)
Nordiska Museet, Stockholm

One of the last of Strindberg's known paintings, *Avenue* is probably inspired by his daily walks in the Djurgården park in Stockholm. The eerie light and oppressive rows of trees, rendered in jaundiced yellow, give the painting a haunting atmosphere, reminiscent of one of his favourite paintings, Arnold Böcklin's *The Isle of Death*. Given that this image was painted towards the end of Strindberg's life, it is tempting to view the avenue as a progression towards the inevitability of death, symbolised by the light on the horizon ('the great unknown' as he described it) pressed between the malevolent sky and darkness of the earth. Like Strindberg's earlier drawings of lumps of coal, the trees seem to be sprouting feet, adding to the feeling that they are sentinels guarding the path to death.

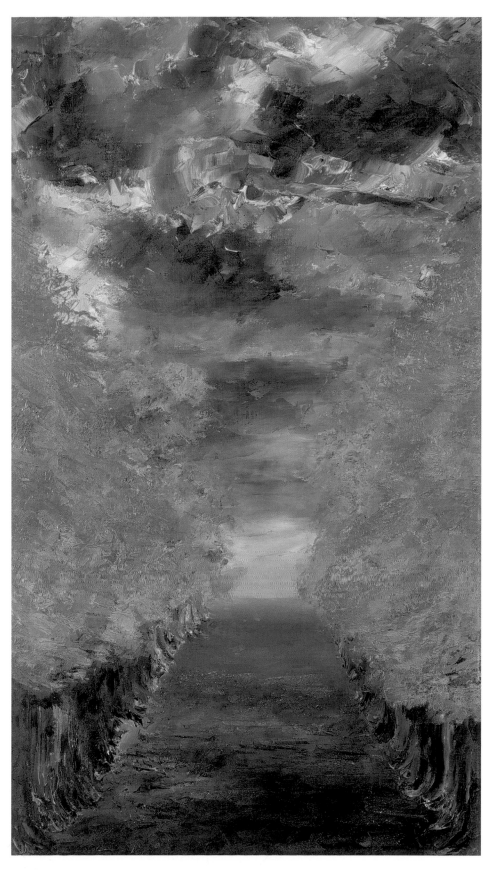

77
The Avenue 1905
Oil on canvas, 94 × 53 (36⅞ × 20⅞)
Thielska Galleriet, Stockholm

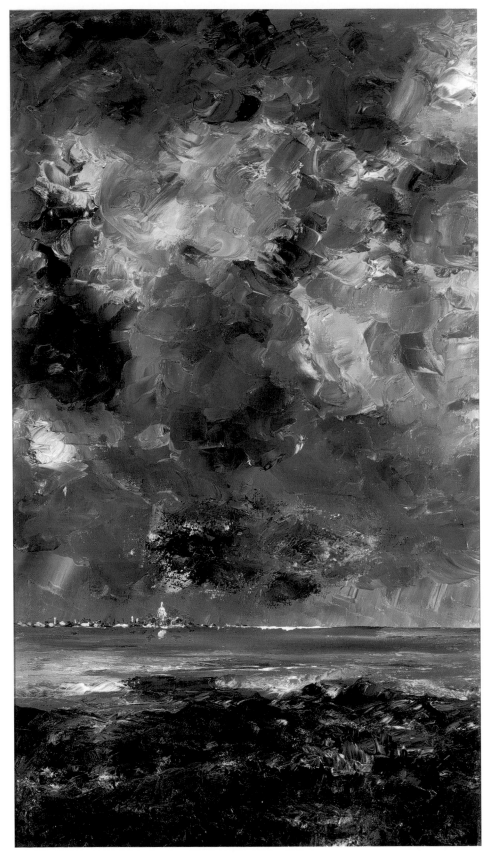

78
The Town 1903
Oil on canvas, 94.5 × 53 (37⅛ × 20⅞)
Nationalmuseum, Stockholm

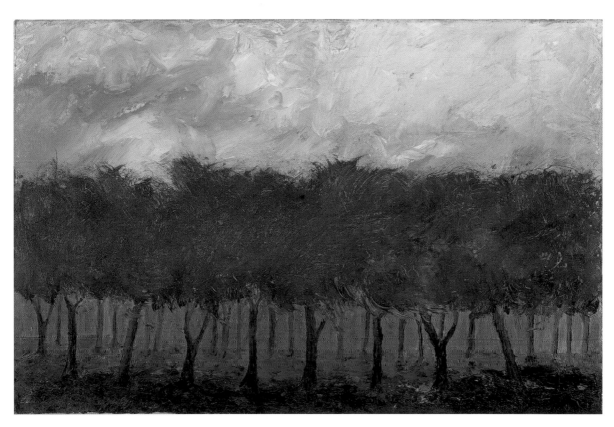

79
Rosendal Gardens II 1903
Oil on canvas, 37 × 54.5 (14½ × 21½)
Göteborg Konstmuseum, Sweden

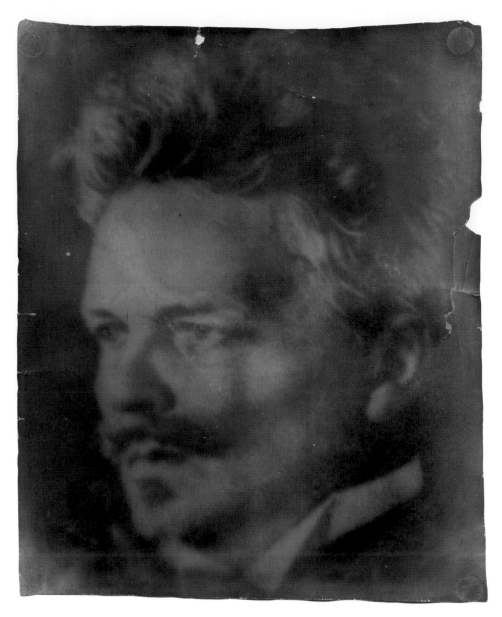

80
Self-Portrait 1906–7
Photograph, 23 × 28.5 (9 × 11 1/8)
Nordiska Museet, Stockolm

Art, science and speculation: August Strindberg's photographics

DAVID CAMPANY

August Strindberg developed an interest in photography in his boyhood in the 1860s and it continued into his final years. As a subject it appeared only occasionally in his writings, and there were few moments when his attitudes to photography aligned with his painting.[1] Nevertheless, throughout the great changes in his life photography remained significant for him. Whether he was preoccupied with science, art, chemistry, alchemy, philosophy, politics, mysticism or magic he saw in it a means of exploration and expression. His photography was always ambitious, often prophetic and frequently erratic. It provided Strindberg, and now provides his audiences, with a parallel position from which to chart the richness of his intellectual and creative work.

Several of Strindberg's most ambitious projects never came to fruition. Even so they leave us tantalising glimpses of his thinking. For example, in 1886 he planned to make a study in words and pictures of rural life in Europe. As an Agrarian Socialist he felt too much attention had been paid the modern metropolis, overlooking the countryside and its people. The idea was to shoot everyday scenes inconspicuously and then combine the images with his writings. Strindberg was an avid follower of new technology but his engagement with cameras and darkrooms was never less than maverick. Many shots were taken for this pioneering project, particularly in France, but errors were made in the exposure and the development. What might have been a landmark ethnographic work in text and image came to little. Had the project succeeded it may have marked the beginning of Swedish photojournalism.

That same year in Gersau spa, Switzerland, he made a characteristic switch in direction. Learning from past errors he embarked on a series of self-portraits.[2] Taken either with a cable release or by his wife, Siri von Essen, he made bold and striking photographs showing the different dispositions of the writer-photographer. We see pride, narcissism and a sense of fun, but also anxiety, doubt and torment. Where many invested photography with a power to capture and summarise an individual, Strindberg saw nothing so simple, especially when it came to describing himself. Even by the 1880s the 'portrait of the author' had hardened into a stale convention, offering little more than promotion for writers and publishers. Strindberg's photographic theatre conjures up a creative

persona that cannot be grasped with any certainty. In some images he is at his writing desk, staring with great intensity into the camera as if into a mirror or his own soul. In others he is a caring family man at peace with the world, a folk musician or a dapper city gent. They have a freshness and sense of play quite out of step with their time, anticipating the complexities of self-image that came to preoccupy twentieth-century art and photography. Strindberg's intention had been to publish the photographs as a companion to *The Author* (*Författaren*) – the fourth volume of his autobiography, *The Son of a Servant*. However, the production costs were prohibitive for such an unprecedented and experimental venture, although the individual photographs survive.[3]

Coming back to Sweden three years later Strindberg returned to the idea of a photographically illustrated social project, this time a study of Swedish nature. The George Eastman Company had recently launched the first box camera, a hand-held model that could take one hundred images on a roll of film. Excited at the possibilities, Strindberg shot extensively. He took full advantage of the small format to make informal and spontaneous images of scenes and people as he encountered them. Again he was ahead of his time. He was also prone to get ahead of himself, tripping up on simple technicalities. On development it seems that he had been shooting not on film but on a roll of photographic paper (which should have been used for making contact prints from negative film).

Even so, it was in many ways his idiosyncratic understanding of the science of photography that led him to see in it unexpected potential and to push it intuitively in new directions. Thus far the medium had offered him a mode of reporting that could parallel and complement his literary descriptions of the social world around him. In Europe in the second half of the nineteenth century, writing and photography became thoroughly intertwined. Novelists turned to intense description of everyday minutiae, producing a 'reality effect' out of the teeming detail of modern life. This way of seeing and thinking suited Strindberg's poetic attraction to truth which he grasped as a series of isolated intensities that flash up somewhere between objective and subjective experience.[4] However, towards the close of the 1880s he was falling prey to something of a writer's block. At

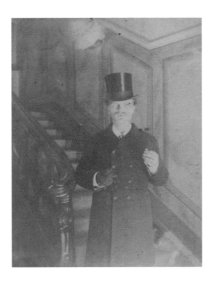

81
Photographs from Gersau 1886
Modern prints from original photographs
Original size, each 18 × 24 (7 × 9 ³/₈)
Strindberg Museum, Stockholm

the same time his fascination with science was growing, intertwined with a much more fantastic interest in alchemy. His photographic activity continued but it took a very different path: moving away from the idea of description, the medium began to appeal to him much more as a means of visionary suggestion.

Perhaps the most intriguing of Strindberg's photographic works are the Celestographs made in 1894. They also provide the clearest overlap with his creative process as a painter. Working on canvas he would attempt to let representations emerge out of the abstract materiality of paint as he manipulated it. He would coax, interpret and respond as a painting progressed in front of him, incorporating 'chance in artistic production' (see p.131). The results hovered between form and formlessness, with paint becoming image only to return to paint again in the mind of the viewer. Something similar is at work in the Celestographs. They were made without a lens or indeed any kind of camera. Instead, sensitised photographic plates were faced directly towards the night sky and left to expose. The results were mottled patches and subtle swirls of blues, browns, greens and golds. In all likelihood they were formed from particles in the air and imperfections in the chemical process. Billowing and gaseous, they certainly resemble the star-strewn heavens seen through clouds. Yet it is difficult to say that they are 'of' the night sky in the familiar sense. Here most of all Strindberg transgressed the very basis of what we think of as a photograph: a direct physical impression of the world through light. Hard proof and factual record give way to a wishful correspondence between image and object. The connection is not physical (what semiotics would call 'indexical') but implied. Titled Celestographs, what we see could be the heavens, or just a patch of ground, or mere photo-chemical stains. For Strindberg they were perhaps all these things at once, indivisibly: the infinite heavens and the earth, base material and the lofty representation, fact and wish. Worldly matter and the stars could resemble each other and be thought as part of the same whole. This certainly went well with Strindberg's interest in the latest scientific accounts of the universe, which suggested a common origin of all the planets and stars. It also fitted his more mystic, religious belief that 'Everything is created in analogies, the inferior with the superior ...'.

82
Celestographs 1894
Modern prints
from original photographs
Original size,
each 12 × 8 (4 ¾ × 3 ⅛)
The Royal Library,
National Library of Sweden,
Stockholm

83
Photogram of Crystallisation
c.1892–6
Modern prints
from original photographs
Original size,
each 12 × 9 (4 ¾ × 3 ½)
The Royal Library, National
Library of Sweden, Stockholm

Strindberg's interest in chemistry grew ever more intensive, and more cameraless images followed. He became absorbed by the way crystalline forms seem to grow almost organically. For him the phenomenon expressed a universalism that connected the animate and inanimate worlds as one. He began to cultivate various salt crystals: brine solutions would be left to evaporate on sheets of glass in the heat or cold. The resulting deposits resembled plant forms reaching out with a living force of their own. These would then be used to make direct contact prints, laying the glass on photographic paper and making an exposure. The photographs were, for Strindberg at least, fixed impressions of mineral 'life' as it grows organically.

The idea of close contact came to dominate his understanding of photography. In 1905, with the assistance of the photographer Herman Anderson, Strindberg attempted to make life-size portraits of heads. Initially this was achieved through re-photographing and enlarging existing images. To him an actual size photograph seemed to offer the opportunity for direct communion or spiritual attachment to the sitter. The physical presence and immediacy of the image suggested a relation that would transcend the cold, objectifying effects of the medium. Scientific discourses saw optics as neutral but Strindberg's attitude was ambivalent. For him the glass lens of the camera was not so much a portal as a source of distortion and subversion. Rather than a means of allowing the world to make its own image, the lens could be a barrier that broke natural connections. At times he shot with a rough, uncut lens. He also built his own pinhole camera (he called it a *Wunderkamera*) with no lens at all. With these he attempted to make what he called 'psychological portraits'. These were long exposures during which sitters would be encouraged to be open to mental suggestion from Strindberg. He felt that by extending the portrait beyond the instant much more of the inner life and personality of the sitter could be expressed. He made several portraits of himself but also left the studio to make many of sitters in their own homes.

Strindberg's final photographs were studies of cloud formations made in 1907. On his morning walks in the city he had seen similar clouds recur in the same places. Still gripped by the idea of correspondence, he saw in these phenomena evidence of deeper order and symbolism amidst

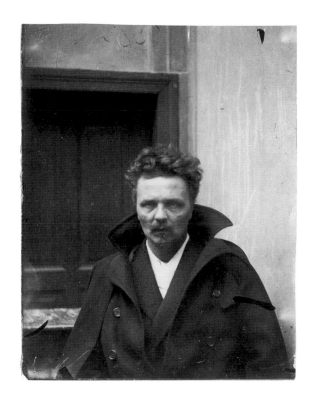

84
Self-Portrait 1892–3
Photograph, 12 × 9 (4³/₄ × 3¹/₂)
The Royal Library, National Library of
Sweden, Stockholm

apparent chaos. Perhaps it was here at last that Strindberg managed reconcile the ineffable and the poetic with the science of photographic description: however accurate a photograph of a cloud, its meaning will remain open to suggestion – that is to say, cloudy.

Strindberg's photographic speculations barely register in the conventional history of the medium. Nevertheless, his work has a place in the counter-story of photography made up of bold beginnings, false starts, intuitive prescience and wild misconception. Certainly it is an easy temptation to disregard his more outlandish claims and conclusions. It is less easy to dismiss the complex forces that directed his thinking. Rational and irrational, mad and tame, they emerge from the profound questions that are within photography itself: What is the relation between appearance and meaning? Does photography offer impartial knowledge or a surface for imaginary projection? Does it have any value outside of conventional uses? These are questions that neither art nor science have entirely contained. Strindberg may well have grasped over a hundred years ago that they never would.

Note

1 The subject of photography appears in two plays by Strindberg: *Creditors* (*Fordringsägare*, 1890) and *The Great Highway* (*Stora Landsvägen*, 1909). In addition, there is the loosely autobiographical short story *Photography and Philosophy* (1903).

2 The series seems to have been inspired by the celebrated publication of a photo-interview with the chemist and colour theorist Michel-Eugene Chevreul. Produced by the photographer Nadar, the sequence appeared in *Le Journal Illustré* in September 1886.

3 Perhaps the closest parallel to this project is *Roland Barthes* by Roland Barthes (1975), the highly reflexive autobiography by the French thinker. Barthes did not shoot his own images but drew upon photographs of himself from his family album and friends.

4 See Nancy Armstrong, *Fiction in the age of photography: the legacy of British realism*, London 1999; Jane M. Raab (ed.), *Literature and photography interactions, 1840–1990: a critical anthology*, Albuquerque 1995; Roland Barthes, 'The Reality Effect' (1968) in *The Rustle of Language*, London 1986

You have challenged me. Fair enough then, I'll rise to your challenge and – en garde!

85
Twelve Impressionist Images, the so-called 'Gersau Album' 1886
Photograph album, 36.7 × 25 (14 1/2 × 9 7/8) closed
Private collection

" — Babebibobubybäbäbó . — Babebibobubybäbäbó . .
Babebibobubybäbäbó — lát xeb . "

[baby talk]

" I väggen var en fönsteröppning, och i den låg
broder Franciscus, stödd på armbågarne och
med halfva kroppen utanför. Han låg på knä
på en bänk och solade sig. "

In the wall there was a window opening and there you could see
brother Franciscus, leaning on his elbows and
with half of his body outside. He was kneeling
on a bench and got a sun-tan.

" - Det hjelper inte att äta gräs !"

It doesn't help to eat grass!

"— Var så god och behåll den minen. Så der! Förträffligt!
Ert ansigte är så rikt på intressanta drag.
— Nå, då äta vi middag tillsammans ute."

Please keep that expression. That's it! Splendid!
Your face is rich in interesting features.
So, let's have dinner together outside.

"Är Du sentimental? ~~Dä~~ frågade Sellén?

'Are you sentimental?' asked Sellén?

"Jo, vi måste bli trädgårdsmästare!"

Yes, we must be gardeners

»– Nu ska jag ha en cing!
– Bort med fingerna! röt gubben och slog till!«

Now I want a five[-point?]!
– Away with your fingers! The old man shouted and slapped!

"Jag bara vill säga: Gud ske lof att den för-
bannade Sommaren är öfver. För mig ska det
få vara vinter hela året!"

I just want to say: Thank God the damned
summer is over. I'd be happy for
it to be winter all year round.

"Kom hit nu din murvel, så ska vi slåss!"

Come on you old hack, let's fight!

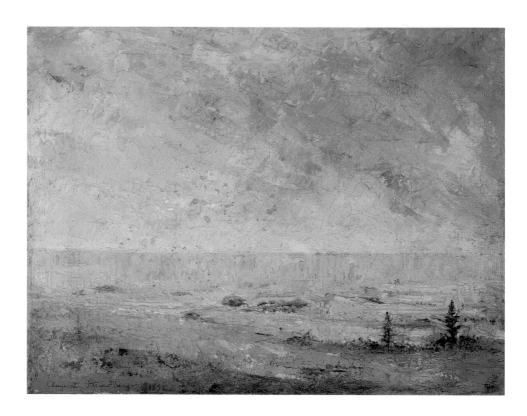

Torch Flower 1892
Oil on canvas, 26 × 34 (10 ¼ × 13 ⅜)
Private collection
[Not exhibited]

New arts! or The role of chance in artistic production
AUGUST STRINDBERG

It is said that the Malays make holes in bamboo trunks that grow in the forests. The wind blows, and the savages lie on the ground to listen to the symphonies performed by these gigantic Aeolian harps. A remarkable thing: each of them hears his own melody and harmony according to the whim of the wind.

Weavers are known to use kaleidoscopes in search of new designs, letting blind chance combine the pieces of stained glass.

Arriving at Marlotte, a well-known artists' colony, I walk into the dining room to look at the celebrated painted panels. What I see there are: portraits of ladies; a) young; b) old, etc. Three ravens on a branch. Very well done. You immediately know what they are. Moonlight. A fairly bright moon; six trees; stagnant, reflecting water. Moonlight, then!

But what is it? – It is that initial question that brings the first thrill of excitement. You must seek, you must conquer; and nothing could be more agreeable than the imagination set in motion.

What is it? Painters call it 'palette scrapings', which means: when work is done, the artist scrapes what is left of his paint and, as the mood takes him, he makes a sketch of some kind. I was delighted by that panel in Marlotte. There was a harmony in the colours, and that was in fact very easily explained, because they had all formed part of a painting. Freed from the constraint of finding colours, the painter's soul is able to devote all its strength to the quest for outlines, and as the hand moves the palette knife at random, following the model of nature without seeking to copy it, the overall picture is revealed as this charming hotchpotch of unconscious and consciousness. It is natural art, in which the artist works as capricious nature does, without a specific goal.

Since then I have occasionally revisited those panels of scrapings, and I have always found something new there, entirely according to my own state of mind.

I was looking for a melody for a one-act play, *Simoun*, which is set in Arabia. To this end I tuned my guitar haphazardly, twisting the screws at random, until I found a chord that struck me as being extraordinarily bizarre without crossing the boundaries of the beautiful.

The tune was accepted by the actor playing the role; but the director, an excessive realist, warned me that the tune was not a real one, and asked me for an authentic melody. I sought out a collection of Arabian songs and performed them

This text was written in French and first published in *La Revue des revues* of 15 November 1894 as 'Des arts nouveaux! ou Le hasard dans la production artistique'.

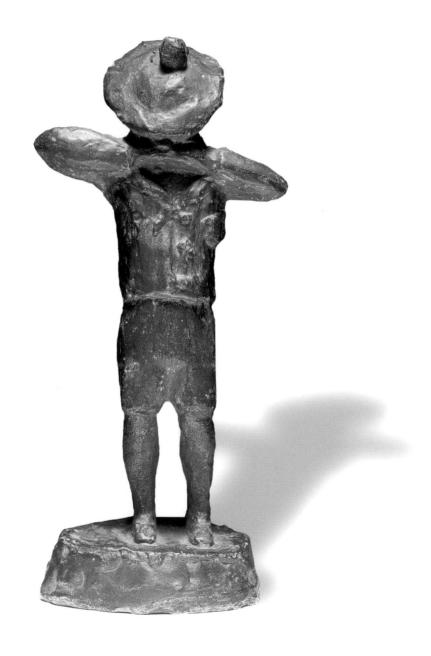

86
The Weeping Boy 1891
Gilded plaster, 20 (7 3/4) high
Private collection

for the director, who rejected them all, finally finding my little Arabian song more Arabic than the ones that were truly Arabian!

The song was sung and enjoyed a certain small success, when a fashionable composer of the day came to ask my permission to provide the accompaniment to my little piece, based on my 'Arabian' tune, which had taken hold of him.

Here is my tune as composed by chance: G, C sharp, G sharp, B flat, E.

I met a musician who amused himself by tuning his piano up and down without rhyme or reason. Then he played by heart Beethoven's *Sonata Pathétique*. It was an incredible delight to hear an old piece rejuvenated. I had heard him playing that sonata for twenty years, always the same, without any hope of seeing it develop: fixed, incapable of evolution.

Since then I have been doing the same with tired old tunes on my guitar. And guitarists envy me, asking me where I got this music, and I reply to them: I don't know. They take me for a composer.

An idea for the manufacturers of those modern portable organs. Pierce the music disc at random, haphazardly, and you will have a musical kaleidoscope.

In his *Life of Animals*, Brehm claims that the starling imitates all the sounds that it happens to hear; the noise of a closing door, the grindstone, the mill, the weather vane, etc. Not a bit of it. I have heard starlings throughout most of Europe and they all sing the same medley, consisting of memories of the jay, the thrush, the fieldfare and other birds of that kind, so that each listener can hear what he likes. The starling, in point of fact, has a musical kaleidoscope.

The same is true of parrots. Why are grey parrots with scarlet tails called Jacob? Because their natural sound, their cry, is 'Iako'. And their owners think they have taught the parrot to speak, starting with its name.

And cockatoos! And macaws! How strange it is to hear an old lady teaching her parrot, as she claims to do. The animal repeats its incoherent cries; the lady, making approximate comparisons, translates, or rather sets lyrics to that accursed music. So, for an outsider, it is impossible to hear what the parrot is 'saying' before he has the words from the mouth of its owner.

I had the idea of moulding a young worshipper in clay, based on a piece of ancient art. There he was, arms aloft; but I took a dislike to him, and in a fit of annoyance I brought my hand down the head of the unfortunate creature. Good heavens! A metamorphosis that Ovid would not have dreamed of. Beneath the blow of my hand, his Greek locks flattened into something like a tam-o'-shanter covering his face; his neck is wedged down between his shoulders; his arms lower so that his hands are level with his eyes, hidden under their bonnet; his legs fold; his knees

meet; and the whole thing becomes a nine-year-old boy crying and hiding his tears with his hands. With a little retouching, the statuette was perfect, which is to say that the spectator received the intended impression.

Later, in the studios of some friends of mine, I improvised a theory of automatic art:

You will remember, gentlemen, the little boy in the folk tales who goes walking in the woods and meets 'the lady of the forest'. She is lovely as the day, with emerald hair and so on. He walks closer and the lady turns her back on him, which looks like the trunk of a tree.

Obviously the boy has only seen the trunk of a tree, and his stirred imagination poetically creates the rest.

As has happened to me many a time.

One fine morning walking in the woods, I come upon a fallow field with a fence around it. My thoughts are elsewhere, but my eyes fall upon a weird and unfamiliar object lying in the field.

One moment it was a cow; the next, a tree trunk, then … I was enjoying this fluctuation of impressions … an act of will, and I want to know more … I feel the curtain of my consciousness rising … but I don't want it to … now it's an al fresco lunch, people are eating … but the figures are motionless, as in a waxworks … ah… that's it … it's an abandoned plough, from which the ploughman has hung his jacket and his pouch! The whole story! Nothing left to see! Vanished delight!

Surely that provides an analogy with the modernist painters, whom the philistines find so hard to understand. At first all you notice is a chaos of colours; then it starts to look like something, there's a resemblance, but no: it doesn't look like anything. All of a sudden a point is fixed like the nucleus of a cell, it grows, colours cluster around it and accumulate; rays form and grow branches and twigs as ice crystals do on windows … and the image presents itself to the spectator, who has witnessed the picture's act of procreation. And even better than that: the painting is always new; it changes with the light, it never tires, it rejuvenates itself, endowed with the gift of life.

I paint in my spare time. In order to be able to dominate the material I choose a middle-sized canvas or, preferably, a piece of board, so that I can finish the painting in two or three hours, for as long as my mood lasts.

I am governed by a vague desire. What I have in mind is the interior of a shadowy forest, through which one can see the sea at sunset.

Fine: with the palette knife I use for the purpose – I have no brushes! – I spread the paints across the card, mixing them together until I have a sort of rough sketch.

The hole in the middle of the canvas represents the horizon of the sea; now the depths of the forest, the foliage, the boughs, begin to emerge in a group of colours, fourteen, fifteen, pell-mell but always in harmony. The canvas is covered; I step back and look! Bother! I can't see the sea anywhere; the brightly-lit opening shows an infinite perspective of pink and bluish light, where ethereal creatures, incorporeal and undefined, float like fairies trailing clouds behind them. The forest has become a dark underground cave, blocked off with brambles: and the foreground – let's see what it is – some rocks covered with lichens that no one could ever find – and there on the right, the knife has smoothed the paint too much, so that it looks like reflections on water – Fancy that! It's a pond! Perfect!

So: above the water there is a patch of white and pink whose origin and meaning I can't work out. One moment! – a rose! – two seconds of work with the knife, and the pond is framed with roses, roses, nothing but roses!

A touch of the finger here and there, blending recalcitrant colours, merging and softening any harsh tones, thinning and blurring, and there's the painting!

My wife, my good friend at the moment, arrives, contemplates the picture, goes into ecstasies over 'Tannhäuser's cave', from which the big serpent (my flying fairies) slips out into this wonderland; and the mallows (my roses!) are reflected in the sulphur spring (my pond!) and so on. For a week she admires the masterpiece, valuing it at thousands of francs, assures me that it should be in a museum, and so on.

After a week we are back in a period of furious antipathy, and she sees my masterpiece as nothing but the purest junk!

And they say that art is a thing for itself!

Have you ever written rhymes? I'm sure you have! You will have noticed what a dreadful job it is. Rhymes fetter the mind; but they also unbind it. Sounds become intermediaries between notions, images, ideas.

This man Maeterlinck, what does he do? He rhymes in the middle of a prose text.

And that degenerate beast of a critic who puts it down to feeble-mindedness, calling his illness by the scientific (!) name of echolalia.

Echolaliacs, all the real poets since the world began. The exception: Max Nordau, who rhymes but isn't a poet. *Hinc illae lacrimae*!

The art to come (and go like all the rest!). To imitate nature more or less; and especially, to imitate nature's way of creating!

Translated by Shaun Whiteside

87
*Photographs of Cloud
Formations* 1907
Modern prints
from original photographs
Original size,
each 12 × 16.5 (4 ¾ × 6 ½)
The Royal Library,
National Library of Sweden,
Stockholm

88
Cloud Formations 1907
Pencil on paper
11 × 19 (4 ⅜ × 7 ½)
The Royal Library,
National Library of Sweden,
Stockholm

Cloud images
AUGUST STRINDBERG

Sky clouds over; clouds move on,
light airships float on the wind
all day, but at evening
pitch their calm tents in the west,
repose in the sun's last flame;
now arise, in playful dress.
Their mirages illude
the dazzled wanderer, deceive
with borrowed charms.

Golden clouds in evening's glow
build ruins, castles on tall hilltop
beside a river valley, its small ravines,
walled vineyards, peachy groves,
cathedrals, council chambers' roofs,
mastersingers' tourneys,
round towers, bridges built on piles ...

Now! Now the scene changes:
a burning disconsolate desert shows
a mounted bedouin who flanks
a caravan on every side;
palms there, oases there,
there pyramids and camels there
mirrored in water as in glass.
Now, now again the scene dissolves,
spreads out in fresh cloudy aspect,
then gathers for the sun to kiss,
is painted, rebuilds as before.

Land! It's land I now behold,
when from the stormy sea I fell
imploring but a grave.
Verdant shores and shady groves,
rushes that sway in a tranquil creek,
here I'm at home among my peers,
here is my land, are my valleys!

Isle, O my sylvan isle,
Basket of flowers on the waves,
Perfumed with new-cut hay, it is you
I saw in my dream;
saw in the friendly fields
lightsome children with flowing tresses
sing and play in opaline flocks
peaceful and lovingly embrace.

Friends and allies I see;
hateful partings of ways,
nor can any recall
what occasioned our tears.
I long to go home, long to leave
this narrow and troublesome earth,
torment of thoughts, hurtful words.
Woe! All's only a cloud.

Clouds, ye children of heaven,
sail on aloft where you are.
Treading earth's crust
never I'll learn to fly!
Betimes black cloudmasses gather,
fall and form puddles of rain
clean yet soiling the earth. I see the wide sky.
How small are the heathland's blue mirrors.

Translated freely by Paul Britten Austin from the rhymed original

89
Stage Set for Mary Stuart,
*sketch c.*1903
Drawing on paper
17.5 × 21 (6⅞ × 8¼)
The Royal Library,
National Library of Sweden,
Stockholm

Mary Stuart: a scenography

Göran Söderström

Strindberg's close friend the painter Richard Bergh, leader of the radical Artists' Association, emphasised the strong visual element in his way of expressing himself:

> Never for a moment in his writings did he, the fiery man of imagination and incisive psychologist, forget surroundings, the natural scenery ... His eye participates incessantly in his descriptions. Parallel with each event there runs an unbreakable logical chain of natural observations, always sketched into his story with a painter's sure eye for concrete effect. He puts them on paper as if with a brush.

As many have observed, Strindberg was a very visually-oriented writer. The characters in his prose works and plays always appear in a masterfully depicted setting, against a distinctive background, with carefully defined lighting and at an exact time of day and year. Even with pen in hand Strindberg was a distinctly visual artist, who was able to capture impressionistic and surrealistic elements of reality and commit them to paper.

With his strong visual disposition it is natural that Strindberg was particularly interested in his plays' scenography. After *Inferno* he made many of his own scenic suggestions in the form of stage design sketches, remarkably enough often for plays that he never wrote. The preponderance of unwritten plays in this material is perhaps due to his treating the existing plays as expendable, to be used and then discarded by directors and scenographers. There is clear evidence that he saw the completed plays in his head before he began writing them, which is why his beautiful calligraphic manuscripts, rarely showing any evidence of textual alteration, are frequently mistaken for final drafts instead of unique originals. A characteristic example is Strindberg's never-written historical drama *Mary Stuart*, conceived in 1901 as an alternative debut for Harriet Bosse, his third wife, to be performed after her pregnancy.

Mary Stuart had long interested him – indeed, ever since his first appearance as an actor at the Royal Dramatic Theatre in 1869 in an insignificant role in Björnstjerne Björnsson's *Maria Stuart*. In his autobiography he wrote that he really had no liking for Mary as a person, but that he was fascinated by Björnsson's play and the fate of its characters. His very first painting, made in Uppsala in 1872, also had as its subject 'Ruin of Tulborn Castle in Scotland where Mary Stuart was imprisoned', a motif taken from an illustrated newspaper.

There are several undated drafts of the play that Strindberg had planned, one of them, in seven tableaux, covering her entire life after her return from France. The others, by contrast, concern her time in prison, how she experienced the changing seasons for a whole year, aware of passing days only by means of sounds, smells, and by watching a streak of sunlight on the floor. 'When death comes closer, the whole of life passes in review. She experiences her past in fantasies.' According to one draft in five tableaux, the action of the first scene is described: 'The smallpox-stricken Darnley

90
Cover for the Draft Manuscript for
'The Secret of the Guild'
1879–80
Ink and watercolour on paper,
32.5 × 24.5 (12³/₄ × 9⁵/₈)
Mörnersamlingen (owner Örebro
Public Library, deposit in
Örebro University Library).

is lying in a four-poster bed with drawn curtains. Mary is reading to him. Bothwell is under the balcony.' In another Mary stands in front of a portrait of Elizabeth, and in another she embroiders and plays the virginals in prison. In the last tableau Strindberg notes 'the confession into the opening in the wall'. Clearly it is this draft that lies behind his detailed sketch for the scene that encapsulates the entire action in the room where she is being held. For inspiration for its furniture Strindberg seems to have drawn on an article torn out of the *Illustrated London News* entitled 'Memories of Holyrood' that particularly describes the queen's room at the castle. The objects on stage indicate how she moves about the scene and relives her life, and the draft calls the other main characters 'shades'.

At this time Strindberg prepared his scenario manuscripts by first putting together a carefully decorated brochure of the text, bound in silk ribbons in various colours – for *Mary Stuart* one red, one black. The number of pages in the brochure show the length of text he had planned, in this case sixty-eight pages. The cover is embellished with the play's title in beautiful lettering coloured with watercolours, after which, on the next double-page spread, is the heading 'Persons', its initial letter in blue, and 'Scenery', its initial in green. (Strindberg has wiped his watercolour brush on the above-mentioned draft.) Then follows the first page of text:

MARY STUART (*standing clad in black at the door at the rear of the stage with a paper in her hand and speaking with someone outside*)
So, my Lord Chancellor, our appeal for mercy is rejected? ... Beyond appeal? ... Very well, may God forgive you all. Most of all the Queen! (*Walks about the room, moves down stage*)

The remaining sixty-six pages are blank.

A loose slip of paper dated 1903 shows that this play was still in Strindberg's mind at the time, although he never wrote any more of it.

His attitude to theatre was that it lived by the spoken word and needed no embellishment: his ideal was 'a table and two chairs', something he stipulated for some of his radical one-act plays. Nevertheless, he could not resist exploiting the possibilities offered by a scenography as part of the whole: although it is striking how little his paintings and scenographic ideas correspond to each other. His twentieth-century paintings, especially many of those made between 1901 and 1903, also have the quality of theatrical backdrops, where the symbolic content is sometimes more important than the technique that elsewhere dominates whatever he wants to express. Despite this, Strindberg's axiom always rings true: that each kind of art has its own mode of expression peculiar to itself, and that these should not be mixed or confused.

Preface to the Paul Gauguin catalogue, 18 February 1895

My dear Gauguin,

You insist on having the preface to your catalogue written by me, in memory of the winter of 1894–95, which we spent here, behind the Institut, not far from the Panthéon, and above all near the Montparnasse cemetery.

I would happily have given you that souvenir to take back to that Island in Oceania where you hope to find a spacious setting in harmony with your powerful stature. But from the outset I feel I am in an equivocal situation, and my immediate response to your request is 'I cannot', or, more brutally, 'I don't want to.'

At the same time, I owe you an explanation for my refusal, which stems not from an unwillingness to oblige or an idleness of the pen, although it would have been easy for me to put the fault down to the already notorious illness in my hands, which has not yet, however, given hair time to grow on my palms.

Here it is:

I cannot grasp your art and I cannot like it. (I have no purchase on your art, which is this time entirely Tahitian.) But I know that this confession will neither surprise nor injure you, for you seem to me to be thoroughly fortified by the hatred of others; in its desire to be left alone, your character takes pleasure in the antipathy that it provokes. And perhaps rightly so, because as soon as you won approval and admiration, as soon as you had supporters, people would classify you, compartmentalise you, your art would be given a label that children under the age of five would use as a nickname for an outmoded kind of art that they would do everything within their power to make yet more outmoded.

I myself have made serious efforts to classify you, to fit you as a link into a chain, to find out something about the course of your development – but in vain.

I remember the first time I stayed in Paris, in 1876. The city was gloomy, for the nation was in mourning for the events that had just taken place, and worried about the future, something was fermenting.

The name of Zola had not yet been heard in Swedish artistic circles, because *L'Assommoir* had not been published; I was present at the performance of *Rome Vaincue* at the Théâtre Français, in which Mme Bernhardt, the new star, was crowned as a second Rachel; and my young artist friends had dragged me along to Durand-Ruel's to see something completely new in painting. A young painter, unknown at the

time, brought me there, and we saw some wonderful canvases, most of them signed Manet and Monet. But as I had other things to do in Paris besides looking at pictures – in my capacity as secretary of Stockholm Library, I was supposed to be searching for an ancient Swedish missal in the Bibliothèque Ste-Geneviève – I looked at this new painting with calm indifference. But I returned the following day, without much of an idea how I got there, and discovered something in those weird manifestations. I saw the swarming of a crowd on to a jetty, but I didn't see the crowd itself, I saw the speeding of a train across some Normandy countryside, the movement of wheels in the street, terrible portraits of very ugly people who had not been able to pose for them peacefully. Gripped by these extraordinary canvases, I sent an article to a newspaper in my country, in which I attempted to capture the sensations that I thought the Impressionists had been seeking to convey, and my article enjoyed a certain success as a piece of gibberish.

By the time I returned to Paris for the second time, in 1883, Manet was dead, but his spirit lived on in a whole school that battled for hegemony with Bastien Lepage; during my third stay in the city, in 1885, I saw Manet's exhibition. By then the movement had asserted itself; it had had its effect, and now it had been classified. At the triennial exhibition, in the same year, complete anarchy. All kinds of styles, colours, themes: historical, mythological and naturalistic. No one wanted to hear any more talk of schools or trends. Freedom was now the rallying cry. Taine had declared that the beautiful and the pretty were not one and the same thing, and Zola that art was a fragment of nature seen through a temperament.

However, in the midst of the last spasms of naturalism, one name was on everyone's lips: that of Puvis de Chavannes. He stood there all alone like a contradiction, painting with the soul of a believer, while at the same time lightly taking into account the taste of his contemporaries for allusion. (We did not yet have the term 'symbolism', a most unhappy term for something so ancient: allegory.)

It was towards Puvis de Chavannes that my thoughts drifted yesterday evening when, to the Mediterranean sounds of the mandolin and the guitar, I saw on the walls of your studio that jumble of sunlit pictures, which haunted me in my sleep last night. I saw trees that no botanist would ever find, animals that Cuvier never dreamed of and human beings that only you could have created. A sea flowing from a volcano, a heaven in which no God could dwell. Monsieur (I said in my dream), you have created a new earth and a new heaven, but I am not happy amidst your creation, it is too sunny for me, since I am a lover of light and shade. And in your paradise there lives an Eve who is not my ideal – for in truth I too have an ideal woman or two!

This morning, I went to the Musée du Luxembourg to take a look at Chavannes, to whom my thoughts were always returning. With profound sympathy I contemplated *Le Pauvre pêcheur*, so attentively seeking the catch that will win him the faithful love of his wife, who is picking flowers, and their lazy child. That is beautiful! But then I spot the crown of thorns. I hate Christ and crowns of thorns. Monsieur, I tell you I hate them. I want nothing of that pitiful god who turns the other cheek. My God, I'd sooner have the Vitsliputsli who devours men's hearts beneath the sun!

No, Gauguin is not formed of the rib of Chavannes, nor of those of Manet nor of Bastien Lepage!

What is he, then? He is Gauguin, the savage who hates an oppressive civilisation, with something of the Titan who, jealous of the creator, creates his own little people in his spare time, the child who takes his toys to pieces to make new ones, the one who denies and defies, who would rather see the sky red than blue, along with the crowd.

But good heavens, it seems that since I have heated myself up by writing, I am starting to have a certain understanding of Gauguin's art.

One modern writer has been reproached for not depicting real beings, but *quite simply* constructing his characters himself. *Quite simply*!

Bon voyage, Maestro: but come back to us and come and see me. Perhaps by then I will have developed a better understanding of your art, which will enable me to write a new preface for a new catalogue in a new Hôtel Drouot, because I too am beginning to feel an immense need to become a savage and create a new world.

Paris, 1 February 1895

August Strindberg

Dear Strindberg

Today I received your letter, the one that is a preface to my catalogue. I had the idea of asking you for this preface when I saw you the other day in my studio, playing the guitar and singing; your blue northern eye gazed attentively at the pictures hanging on the walls. I had something like the premonition of a revolt: a real collision between your civilisation and my barbarism.

Civilisation, which makes you suffer. Barbarism, which is for me a rejuvenation.

Before my chosen Eve, whom I have painted in the forms and harmonies of another world, the memories of your choosing may have conjured up a distressing past. The Eve of your civilised conception turns you and almost all of us into misogynists: the old Eve, the one who frightened you in my studio, might one day smile at you less bitterly. This world that not even Cuvier, nor any botanist, might be able to find, is a Paradise that I have merely sketched. And it is a long way from the sketch to the realisation of the dream … Never mind! Isn't a glimpse of happiness a foretaste of Nirvana?

Logically speaking, the Eve that I painted (and she alone) can stand before us naked. Yours in that simple condition could not walk without shame, and, being too beautiful (perhaps), would evoke evil and sorrow.

To help you understand my thoughts a little better, I shall stop comparing these two women directly; but the language, Maori or Turanian, spoken by my Eve, and the language spoken by the women you have chosen from them all, an inflecting language, a European language.

In the languages of Oceania, with elements preserved in all their rawness, isolated or fused together without concern for polish, all is naked, radiant and primordial.

While in the inflecting languages, the roots from which, like all languages, they began, are obliterated by the daily business that has worn their relief and their contours. It is a sophisticated mosaic, in which the joins between the stones, more or more crudely lumped together, can no longer be seen, leaving only a lovely painting in stone for us to admire. Only the practised eye can discover the process of its construction. Forgive this lengthy philological digression: I think it necessary to explain the wild drawing that I have had to employ to describe a country and a people speaking Turanian.

It remains to me, dear Strindberg, to thank you.

When will we see one another again?

Until that day, as today, from the bottom of my heart

Paul Gauguin

Translated by Shaun Whiteside

Chronology

Note

This biography does not claim to be in any way comprehensive, but is intended to give a good idea of Strindberg's many-sidedness and his roving, restless life. His collected works take up many metres of bookshelves, his published correspondence – all of it written by hand with a pen dipped in ink – almost as much again. As part of this enormous output, his paintings are but a small, albeit important ingredient, but they meant much to Strindberg himself. Göran Söderström, in his study of Strindberg as a painter, estimates that he made some 120 paintings, of which fewer than ten are lost.

91
Landscape Study, Kymmendö 1872
Pencil on paper, 27 × 22 (10 ⁵/₈ × 8 ³/₄)
Göteborg University Library

92
Cottage with Turf Roof 1873
Pencil on paper, 7.2 × 16 (6 ³/₄ × 6 ¹/₄)
Nordiska Museet, Stockholm

1849 Johan August Strindberg born in Stockholm on 22 January, third son of a steamboat commissioner, Carl Oscar Strindberg, and his wife, Nora. August's birth was followed by those of another boy and three girls.

1862 Death of his mother; his father subsequently marries the housekeeper.

1867 Graduates from school in Stockholm with a General Certificate of Education and enrolls at Uppsala University to study aesthetics and modern languages. Unhappy with academic studies, he soon returns to Stockholm where he finds employment as a private tutor in two separate doctors' residences.

1869 Spends the summer in Stockholm with a group of young bohemians, many of them painters. In particular, he gets to know Per Ekström, an artist for whom the influences of Impressionism would later secure a respectable place in Swedish painting. In Uppsala a fellow student had introduced Strindberg to painting; now, under the guidance of Ekström, he pursues this interest. This year he also studies chemistry, hoping to qualify for medical school, but fails his exam in Uppsala, whereupon he gives up any further ambitions of becoming a doctor. Instead he applies to the National Stage for Orators to be an actor, but is once more turned down.

1870 At the end of the 1860s, Strindberg begins writing for the stage and in 1870 has his drama *In Rome* (*I Rom*) performed on the stage of the very theatre that had rejected him as an actor.

1871 In the summer he visits Kymmendö, an island in the Stockholm Archipelago that is to become a mainstay in his otherwise footloose existence, for the first time. Kymmendö and its populace form the basis for *The People of Hemsö* (*Hemsöborna*, 1887), the most loved of all his novels. One more play, *The Outlaw* (*Den Fredlöse*), is put on at the Royal Dramatic Theatre; Strindberg is awarded a royal grant.

1872 In the spring Strindberg paints his first known painting, *The Ruin of Tulborn Castle*, depicting a castle in Scotland where Mary Stuart had lived. This painting has since disappeared. Spends the summer back on Kymmendö, drawing from nature and completing his drama *Master Olof* (*Mäster Olof*): he sends this in to the Royal Dramatic Theatre, where it is promptly rejected.

1873 Makes a short-lived, less than successful attempt at being an editor for the *Swedish Insurance News*, an experience that will leave its traces in his novel *The Red Room* (*Röda Rummet*) some years later. Another summer on Kymmendö, followed by an autumn in Sandhamn, another of Strindberg's favourite spots in the Archipelago, captured both in drawings and paintings.

1874 For a few years Strindberg writes for the newspaper

93
Carl Larsson 1853–1919
August Strindberg 1899
Charcoal and oil on canvas, 56 × 39 (22 × 15 3/8)
Nationalmuseum, Stockholm

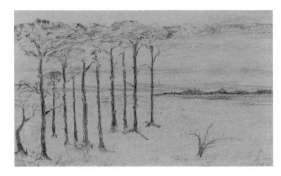

94
Landscape with Pine Trees c. 1900
Crayon on cardboard, 16.5 × 25 (6 1/2 × 9 7/8)
Nordiska Museet, Stockholm

Dagens Nyheter, primarily theatre and art reviews. In the autumn of this year he works as an assistant librarian at the Royal Library in Stockholm, which does much for his diversified knowledge in a variety of disciplines.

1876 Goes to Paris for the first time, where he sees the Impressionist paintings at the Durand-Ruel gallery, resulting in his writing an article on them in *Dagens Nyheter*, much ahead of its time.

1877 In December marries Siri von Essen, who has left her husband for him.

1878 Rewrites *Master Olof* in verse.

1879 Publishes *The Red Room*, a severe criticism of contemporary society. This highly realistic novel makes Strindberg a leading figure for young, radical Sweden.

1882 Collaborates with his artist friend Carl Larsson, on a book, *The Swedish People (Svenska Folket)*, an historical chronicle, illustrated by Larsson under Strindberg's close supervision. They work together all summer on Kymmendö.

1883 Travels with his growing family, two daughters aged two and three and another baby on the way, down to an international artists' colony at Grez-sur-Loing near Fontainebleau. Among many other Scandinavians Carl Larsson is also there along with his fiancée.

1884 Spends a year in various resorts in Switzerland. Writes *Married (Giftas)*, a collection of short stories for

which he is prosecuted for blasphemy but subsequently acquitted.

1885 Returns to France (Paris, Luc-sur-Mer and Grez-sur-Loing), where he plans to write a descriptive account of the French peasantry to be illustrated with photographs. However, collaboration with the photographer breaks down.

1886 This itinerant lifestyle is continued in Germany and Switzerland. Stays at Gersau by the Vierwaldstätter, where he takes photographs of himself and his family. Starts work on his autobiographical novel *The Son of a Servant (Tjänstekvinnans son)*.

1887 *The People of Hemsö* is published and is a great success. The first steps are taken in the drawn-out divorce proceedings between himself and his wife. Starts writing *A Fool's Defence (Le Plaidoyer d'un Fou)* in French.

1889 The family settles in Copenhagen, where Strindberg has already set up an experimental theatre the previous autumn. *Miss Julie (Fröken Julie)* is performed with Siri von Essen in the lead role. In the course of the next two years *Creditors (Fordringsägare)*, *The Stronger (Den Starkare)* and *Pariah (Paria)* are also put on there. *By the Open Sea (I Havsbandet)*, a novel much influenced by Nietzschean thought, is published. The summer is spent at Sandhamn.

1890 *Master Olof* appears on the national stage to wide

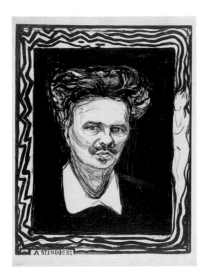

95
Edvard Munch 1863–1944
August Strindberg 1896
Lithograph, 60.5 × 46 (24 1/8 × 18)
Munch-museet, Oslo

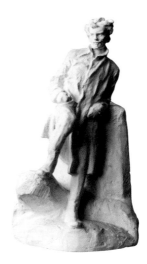

96
Carl Eldh 1873–1954
The Young Strindberg in the Archipelago 1908
Plaster, 41 (16 1/8) high
Carl Eldhs Ateljémuseum / The Carl Eldh Studio Museum, Stockholm

acclaim. The summer is spent sketching on Runmarö,
a new resort in the Archipelago.

1891 The divorce is finalised. Strindberg returns to
Runmarö. The autumn is spent sculpting on Dalarö
(none of these sculptures has survived). He later moves
to the Stockholm suburb of Djursholm where he makes
his only two extant sculptures.

1892 Moves back to Dalarö in April. This is his most
prolific period as a painter: some thirty or so paintings
survive from this period. Exhibits in Stockholm at the
end of the summer, but his artistic debut has a lukewarm
reception. Travels to Berlin in the autumn, where he
quickly becomes a central figure in the group of artists
who gather in the wine bar which Strindberg calls
Zum Schwarzen Ferkel (the Black Piglet). Here he meets
Edward Munch and is a first-hand witness to the so-
called Munch Affair, when the Norwegian's exhibition
so scandalises the art establishment that it is closed
down. Strindberg produces a number of paintings in
Berlin and Weimar during the winter of 1892–3.

1893 In April Strindberg leaves Berlin with Frida Uhl, a
young journalist whom he marries in Helgoland. The
honeymoon takes them to London, where Strindberg
probably sees the work of J.M.W. Turner; he will later
describe Turner as being the greatest of all English
artists. That autumn Strindberg and his pregnant wife

move in with her parents in Dornach, Austria. Here he
carries out photographic experiments which he calls
'Celestographs', exposing photographic plates to the
night sky, 'without camera or lenses'. He sends a
selection of these to the astronomer Flammarion in
Paris, who puts them on show and in May 1894
discusses them at a conference at Societé Astronomique
de France. Sixteen of Strindberg's Celestographs are
now in the Royal Library, Stockholm.

1894 His daughter Kerstin is born in Dornach. Here
Strindberg paints the landscape around the Danube,
saying that he wants his child to be born in a beautiful
home. But the marriage is already on the rocks and in
August he goes to Paris alone. There he meets with
success with Lugné-Poes' productions of *Creditors*
(*Fordringsägare*) and *The Father* (*Fadren*) at the Théatre de
l'Oeuvre. In the autumn he borrows an apartment in
Passy where he paints. His essay 'New arts! or The role
of chance in artistic production' ('Des arts nouveaux!
ou Le hasard dans la production artistique') is published
in the magazine *Revue des revues* on 15 November
(see p.131–5). Becomes increasingly engrossed in
scientific experiments, attempting among other things
to prove that sulphur is not an element, and that it is
possible to make gold. He writes about this, in German,
in *Antibarbarus*.

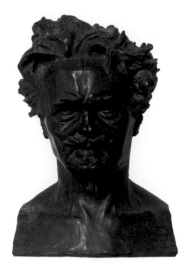

97
Carl Eldh 1873–1954
Portrait of the Writer August Strindberg 1905
Bronze, 64 (25¼) high
Moderna Museet, Stockholm

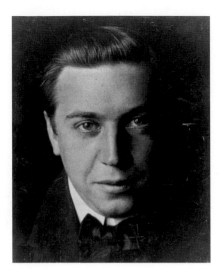

98
Herman Anderson 1856–1909
Portrait of August Falck 1908
Photographs, 35 × 28 (13¾ × 11)
Strindberg Museum, Stockholm

1895 Alone in Paris, Strindberg seeks the company of two Swedish sculptresses, Agnès de Frumerie and Ida Ericsson-Mollard, the latter married to a French civil servant. Their neighbour is Paul Gauguin, who is about to sell his paintings in order to finance his second – and last – trip to Tahiti. Strindberg is invited to write a preface for the auction catalogue; he declines in a letter so well-formulated, that Gauguin asks to use it, along with his own reply, in the catalogue (see pp.142–5). Strindberg's persistent scientific experimentation is probably the cause of severe eczema on his hands; he is hospitalised, at the Saint Louis hospital in Paris. He experiences his so-called 'inferno crisis', when he is increasingly drawn toward the occult and theosophism, and gradually also toward Catholicism, although he never goes so far as to convert.

1896 Crisis, persecution mania and science take over. Seeks relaxation at a friend's house in the south of Sweden during the summer. Spends the autumn in Austria with his parents-in-law, who are looking after his daughter, Kerstin, now two and a half years old. Immerses himself in the study of Emmanuel Swedenborg and his doctrine of correspondences and starts writing his *Occult Diary* (*Ockulta dagboken*).

1897 Spends the summer in Lund in the south of Sweden, writing *Inferno*. Returns to Paris in the autumn and

writes *Inferno II* or *Legends* (*Legender*), as it came to be called in print.

1898 Writes his play *To Damascus I* (*Till Damaskus I*). Goes back to Lund in April, where he writes his short novel *The Cloister* (*Klostret*), about his second marriage.

1899 Leaves Lund and returns to Stockholm. Spends the summer in the Archipelago at Furusund.

1900 Spends the summer in Furusund. His play *Gustavus Adolphus* (*Gustav II Adolf*), said to be unplayable, is a failure.

1901 Writes the dramas *The Dance of Death* (*Dödsdansen*) and *Easter* (*Påsk*), as well as the fourth version of *To Damascus*. Marries the actress Harriet Bosse, who almost immediately asks for a divorce, pregnant though she is with Strindberg's fifth child. Just as in Dornach in 1894, the expected baby stirs Strindberg's desire to paint, among other canvases, *The Child's First Cradle*, the very similar *Yellow Autumn Painting* and *Inferno*.

1902 Returns to painting motifs from the Stockholm Archipelago, such as *The Lighthouse*. Writes for the stage, creating parts for his young wife. In March, daughter Anne-Marie is born.

1903 The Rosendal Gardens in Djurgården become a new destination for Strindberg's walks. Here he finds fresh themes for his painting.

1904 Furious conflicts with the Establishment in his novel

99
Glass Bowl Used for Making Gold c.1897–9
Glass, 41 (16¹/₈) high
Museum for Science and Technology, Stockholm

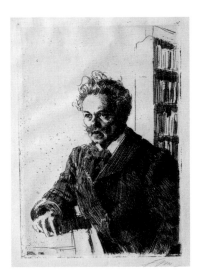

100
Anders Zorn 1860–1920
August Strindberg 1910
Etching, 29.9 × 19.9 (11⁷/₈ × 7³/₄)
Nationalmuseum, Stockholm

The Gothic Rooms (Götiska Rummen). His divorce from Harriet is officially ratified.

1905 Summer in Furusund. Models for his new-found friend, the young sculptor Carl Eldh, and for his old friend the painter Richard Bergh. The art collector and patron Ernest Thiel adds three paintings to his collection of turn-of-the-century Nordic painting. No more paintings by Strindberg are dated after this year.

1906 Builds himself a camera and turns his attentions to life-size photographic portraits, including some of himself. Works with the photographer Herman Andersson. Draws clouds outside his window on Karlaplan. Scientific research published in *Antibarbarus*. Starts to write his *Blue Books*.

1907 Produces photographic studies of clouds with Hermann Andersson. *A Dream Play (Drömspelet)* is performed on the national stage, with Harriet Bosse in the role of Indra's daughter, and is well received. In November the Intimate Theatre, which Strindberg founded with the young August Falck, opens to the public. *Black Banners (Svarta fanor)* is published, causing another furore.

1908 Moves to his last residence in Stockholm, the Blue Tower, now the Strindberg Museum.

1909 Exhibition of his paintings held in the Intimate Theatre to celebrate his sixtieth birthday. His last play,

The Great Highway (Stora Landsvägen) is published.

1910 The so-called 'Strindberg feud' between radicals and conservatives in Swedish literature. Strindberg and his former friend the poet Verner von Heidenstam personify the two opposites.

1911 Summer exhibition in Stockholm arranged by his friend the painter Karl Nordström. A national appeal for money is set up for Strindberg. The publishing house Albert Bonniers purchases the copyright to his entire oeuvre, making him financially independent.

1912 Dies of stomach cancer on 14 May; his funeral on 19 May is a day of national mourning. According to his wish, Strindberg is buried beneath a number of wooden crucifixes with the inscription: *O Crux Ave Spes Unica.*

Bibliography

WORKS BY STRINDBERG
Chronological by date of first publication

Married, trans. Thomas Seltzer, New York n.d.

Countess Julia (Fröken Julie): a naturalistic tragedy, trans. Charles Recht, Philadelphia 1912

Stories and Poems, ed. with introduction, notes and vocabulary by Joseph E.A. Alexis, Stockholm 1924

Zones of the Spirit : a Book of Thoughts, trans. Claud Field, introduction by Arthur Babillotte London 1913

The Road to Damascus: a Trilogy, trans. Graham Rawson, introduction by Gunnar Ollén, New York 1958

The Natives of Hemsö, trans. Arvid Paulson, New York 1965

The Son of a Servant: The Story of the Evolution of a Human Being 1849–67, trans. with introduction and notes by Evert Sprinchorn, London 1966

The Cloister. ed. C.G. Bjurström, trans. with commentary and notes by Mary Sandbach, London 1969

Strindberg's one-act plays, trans. Arvid Paulson, introduction by Barry Jacobs, New York 1969

Strindberg: a Collection of Critical Essays, ed. Otto Reinert, Englewood Cliffs, NJ 1971

The Confession of a Fool, trans. Ellie Schleussner, New York 1972

A Dream Play, adapted by Ingmar Bergman, trans. with introduction by Michael Meyer, London 1973

Inferno and From an Occult Diary, selected by Torsten Eklund; trans. with introduction by Mary Sandbach, Harmondsworth 1979

Plays, I, *The Father; Miss Julie; The Ghost Sonata*, trans. Michael Meyer, London, 1982

By the Open Sea, trans. with introduction by Mary Sandbach, London 1987

Plays, II, *The Dance of Death; A Dream Play; The Stronger*, trans. Michael Meyer, London 1988

Plays, III, *Master Olof; Creditors; To Damascus (Part 1)*, trans. Michael Meyer, London 1991

Strindberg's Letters, I, *1862–1892* and II, *1892–1912*, selected, ed. and trans. Michael Robinson, London 1992

The Pelican & The Isle of the Dead, trans. with introduction and notes by Michael Robinson, Birmingham 1994

Miss Julie, trans. S.H. Landes, ed. with introduction by William-Alan Landes, Studio City, CA 1996

Selected Essays, selected, ed. and trans. Michael Robinson, New York 1996

The Father, adapted by Richard Nelson, London 1998

Miss Julie and Other Plays, trans. Michael Robinson, Oxford 1998

Miss Julie, trans. Helen Cooper, London 2000

The Plays, I, trans. Gregory Motton, London 2000

Selected Poems of August Strindberg, ed. and trans. Lotta M. Löfgren, Carbondale, IL 2002

The Father; trans. E. and W. Oland, Mineola, NY 2003

The Plays. II, trans. Gregory Motton, London 2004

CATALOGUES
In chronological order

Strindberg: diktare, bildkonstnärer, Nationalmuseum, Stockholm 1974

Images from the Strindberg Planet, Venice 1980

August Strindberg, Rijksmuseum Vincent van Gogh, Amsterdam 1987

August Strindberg, Underlandet, Malmö Konsthall, Malmö 1989

August Strindberg, Carl Kylberg, Max Book, Liljevalchs Konsthall, Stockholm 1992

Border Crossings: Fourteen Scandinavian Artists, Barbican Art Gallery, London 1992

Strindberg, IVAM centre, Julio González 16 February – 2 May 1993, trans. Kjersti Board, IVAM, Valencia 1993

Ljusbilder-svartkonster: fotografiska experiment av August Strindberg, 20 May – 15 August 1993, Stenströms galleri och café, Stockholm 1993

Strindberg och fotokonsten, Strindbergmuseet, Stockholm 1995

Art noir: camera work by: valokuvaajina: Edvard Munch, Akseli Gallen-Kallela, Hugo Simberg, August Strindberg, trans. Jüri Kokkonen, Gallen-Kallelan museo, Helsinki 1995

Lumière du monde, lumière du ciel, Musée d'art moderne, Paris 1998

Strindberg: Painter and Photographer, ed. Per Hedström, trans. Nancy Adler, New Haven and London 2001

BOOKS
Alphabetical by author

Christian Berg, Frank Durieux and Geert Lernout (eds), *The Turn of the Century: Modernism and Modernity in Literature and the Arts [Le tournant du siècle : le modernisme et la modernité dans la littérature et les arts]*, Berlin 1995

Harry G. Carlson, *Out of Inferno: Strindberg's Reawakening as an Artist*, Washington 1996

Douglas Feuk, *August Strindberg: Inferno Painting: Pictures of Paradise*, trans. Kjersti Board, Hellerup 1991

Per Hemmingsson, *August Strindberg – the Photographer: an Essay*, Åhus 1989

Olof Lagercrantz, *August Strindberg*, trans. Anselm Hollo, London 1984

Frederick J. Marker, *Strindberg and Modernist Theatre : post-Inferno Drama on the Stage*, Cambridge 2002

Michael Meyer, *Strindberg : a Biography*, Oxford 1987

Michael Robinson, *Strindberg and Autobiography: Writing and Reading a Life*, Norwich 1986

Freddie Rokem, *Strindberg's Secret Codes*, Norwich 2003

Robert Rosenblum, *The Paintings of August Strindberg: the Structure of Chaos*, Hellerup 1995

Rolf Söderberg, *Edvard Munch, August Strindberg: photography as a tool and an experiment*, trans. Jan Teeland, Stockholm 1989

Göran Söderström, *Strindberg Måleri. En monografi*, catalogue raisonné ed. Torsten Måtte Schmidt, Malmö 1972

Göran Söderström, *Strindberg och bildkonsten*, Stockholm 1990

Elizabeth Sprigge, *The Strange Life of August Strindberg*, New York 1972

Anna Westerståhl Stenport, *Making Space: Stockholm, Paris, and the Urban Prose of Strindberg and his Contemporaries*, Berkeley, CA 2004

List of exhibited works

In chronological order

PAINTINGS

Beach, Kymmendö I 1873
Strandparti, Kymmendö, I
Oil on cardboard
16 × 26 (6¼ × 10¼)
Private collection
(16)

Beach, Kymmendö II 1873
Strandparti, Kymmendö, II
Oil on wood
17.5 × 24.5 (6⅞ × 9⅝)
Örebro Konsthall, Sweden
(17)

Beach, Sandhamn 1873
Strandparti, Sandhamn
Oil on cardboard
15.5 × 18.5 (6⅛ × 7¼)
Nordiska Museet, Stockholm
(18)

Storm after Sunset at Sea 1873
Efter solnedgång under oväder på havet
Oil on canvas
12 × 25 (4¾ × 9⅞)
Private collection
(19)

Skerry with Lighthouse 1873
Skär med fyr
Oil on canvas
12.5 × 31 (4⅞ × 12⅛)
Private collection
(21)

Eclipse 1891
Solförmörkelse
Oil on cardboard
11 × 17 (4¾ × 6⅝)
The Royal Library,
National Library of Sweden, Stockholm
(22)

Polar Light 1891
Polarljus
Oil on cardboard
11 × 17 (4⅜ × 6⅝)
The Royal Library,
National Library of Sweden, Stockholm
(22)

The Wave I 1892
Vågen I
Oil on cardboard
8 × 7 (3⅛ × 2¾)
Private collection
(23)

Lighthouse 1892
Blänkfyren
Oil on cardboard
6.5 × 18 (2½ × 7)
The Royal Library,
National Library of Sweden, Stockholm
(20)

Double Picture 1892
Dubbelbild
Oil on cardboard, collage
40 × 34 (15¾ × 13⅜)
Private collection
(37)

Mysingen 1892
Mysingen
Oil on cardboard
45 × 36.5 (17¾ × 14⅜)
Bonniers Portrait Collection,
Nedre Manilla, Stockholm
(25)

Broom Buoy I 1892
Ruskprick I
Oil on cardboard
8.5 × 7.5 (3⅜ × 3)
Amells Stockholm – London
(24)

Stormy Sea. Broom Buoy 1892
Stormigt hav. Ruskprick
Oil on cardboard
31 × 19.5 (12⅛ × 7⅝)
Nationalmuseum, Stockholm
(26)

In the Archipelago 1892
I havsbandet
Oil on zinc
43 × 62 (17 × 24½)
Private collection
(55)

Sea-Scape 1892
Havslandskap med skär
Oil on zinc
43 × 62 (17 × 24½)
Private collection
(56)

The White Mare II 1892
Vita Märrn II
Oil on cardboard
60 × 47 (23⅝ × 18½)
Nationalmuseum, Stockholm
(28)

The Sounding Buoy 1892
Ljudbojen
Oil on paper
8 × 6 (3⅛ × 2¼)
Private collection
(9)

The Lonely One 1892
Enslingen
Oil on cardboard
30 × 19 (11⅞ × 7½)
Private collection
(54)

Stormy Sea. Buoy without Top Mark 1892
Stormigt hav. Slätprick
Oil on cardboard
31 × 19 (12⅛ × 7½)
Nationalmuseum, Stockholm
(27)

Blizzard 1892
Snötjocka
Oil on wood, 24 × 33 (9⅜ × 13)
Prins Eugens Waldemarsudde, Stockholm
(34)

Flower on a Beach 1892
Blomman vid stranden
Oil on zinc, 20 × 32 (7¾ × 12⅝)
Manassas Foundation
(46)

Flower on the Shore, Dalarö 1892
Blomman vid stranden, Dalarö
Oil on zinc, 24.7 × 43.5 (9¾ × 17⅛)
Malmö Konstmuseum / Malmö Artmuseum,
Sweden
(47)

Beach, Summer Night 1892
Strand i sommarnatt
Oil on zinc, 20 × 32 (7¾ × 12⅝)
Private collection
(49)

Little Water, Dalarö 1892
Lite vatten
Oil on cardboard, 22 × 33 (8¾ × 13)
Nationalmuseum, Stockholm
(35)

Purple Loosestrife 1892
Fackelblomster
Oil on canvas, 35 × 56 (13¾ × 22)
Private collection
(45)

Torch Flower No 1 1892
Fackelblomster
Oil on cardboard, 9 × 18.5 (3.5 × 7¼)
Private collection
(50)

Storm in the Archipelago (The Flying Dutchman)
1892
Oväder i skägården (Den flygande holländaren),
Dalarö
Oil on cardboard
62 × 98 cm (24 ¹/₂ × 38 ⁵/₈)
Statens Museum for Kunst, Copenhagen
(32)

The Solitary Thistle 1892
Den ensamma tisteln
Oil on cardboard, 19 × 30 (7 ¹/₂ × 11 ⁷/₈)
Private collection
(48)

Night of Jealousy 1893
Svartsjukans natt
Oil on cardboard
41 × 32 (16 ¹/₈ × 12 ⁵/₈)
Strindberg Museum, Stockholm
(70)

Palette with Solitary Flower on the Shore 1893
Palett med ensam blomma på stranden
Oil on wood, 38 × 34 (15 × 13 ³/₈)
Private collection
(1)

Waves c.1893
Vagen
Oil on board, 47.4 × 39.3 (18 ⁵/₈ × 15 ¹/₂)
Private collection
(57)

The Danube in Flood 1894
Oversvämning vid Donau
Oil on panel, 44 × 33 (17 ³/₈ × 13)
Private collection
(67)

The Verdant Island II 1894
Den grönskande ön II
Oil on cardboard, 39 × 25 cm (15 ³/₈ × 9 ⁷/₈)
Strindberg Museum, Stockholm
(68)

Golgotha, Dornach 1894
Golgata
Oil on canvas, 91 × 65 (35 ⁷/₈ × 25 ¹/₂)
Private collection
(36)

Wonderland 1894
Underlandet
Oil on cardboard, 72.5 × 52 (28 ⁵/₈ × 20 ¹/₂)
Nationalmuseum, Stockholm
(62)

Alpine Landscape I 1894
Alplandskap I
Oil on cardboard, 72 × 51 (28 ³/₈ × 20)
Private collection
(69)

Flower on the Beach, Paris-Passy 1894
Blomman vid stranden
Oil on cardboard, 29 × 42 (11 ³/₈ × 16 ¹/₂)
Private collection
(51)

Shore Scene 1894
Strandbild
Oil on cardboard, 26 × 39 (10 ¹/₄ × 15 ³/₈)
Strindberg Museum, Stockholm
(44)

Seascape with Rock 1894
Marin med Klippa
Oil on wood, 40 × 30 (15 ³/₄ × 11 ⁷/₈)
Musée d'Orsay, Paris; Don de Karl Otto Bonnier
et de ses enfants par l'intermédiaire des Amis du
Musée d'Orsay, 2002
(71)

Ruin 1894
Ruin
Oil on panel, 39 × 26.3 (15 ³/₈ × 10 ³/₈)
Private collection
(15)

Snow Storm at Sea 1894
Snöstorm på havet
Oil on cardboard, 66 × 47 (26 × 18 ¹/₂)
Nordiska Museet, Stockholm
(72)

High Seas 1894
Hög sjö
Oil on cardboard, 96 × 68 (37 ³/₄ × 26 ³/₄)
Folkhem Konstsamling
(33)

The Child's First Cradle 1901
Barnets första vagga
Oil on paper, 45 × 38 (17 ³/₄ × 15)
Private collection
(66)

Inferno 1901
Inferno-tavlan
Oil on canvas, 100 × 70 (39 ³/₈ × 27 ¹/₂)
Private collection
(65)

The Yellow Autumn Painting 1901
Den gula hösttavlan
Oil on canvas, 54 × 35 (21 ¹/₄ × 13 ³/₄)
Manassas Foundation
(64)

The Wave V 1901
Vågen V
Oil on canvas, 101 × 70 (39 ³/₄ × 27 ¹/₂)
Private collection
(60)

The Wave VII 1901
Vågen VII
Oil on canvas, 57 × 36 (22 ³/₈ × 14 ¹/₈)
Musée d'Orsay, Paris
(59)

The Lighthouse II, Stockholm 1901
Fyrtornet II, Stockholm
Oil on canvas, 100 × 71 (39 ³/₈ × 28)
Private collection
(30)

The Lighthouse III 1901
Fyrtornet III
Oil on canvas, 99 × 69 (39 × 27 ¹/₈)
Uppsala University Collection
(31)

The White Mare IV 1901
Vita Märrn IV
Oil on wood, 51 × 30 (20 × 11 ⁷/₈)
Örebro Konsthall, Sweden
(29)

The Wave VI (verso: The Wave VIII) 1901–2
Vågen VI (verso: Vågen VIII)
Oil on canvas, 100 × 70 (39 ³/₈ × 27 ¹/₂)
Nordiska Museet, Stockholm
(58)

The Wave VIII (recto: The Wave VI) 1901–2
Vågen VIII (recto: Vågen VI)
Oil on canvas, 100 × 70 (39 ³/₈ × 27 ¹/₂)
Nordiska Museet, Stockholm
(101)

Flowering Wall c.1901
Oil on canvas, 52 × 36 (20 ¹/₂ × 14 ¹/₈)
Private collection
(52)

The Wave IX c.1901
Vagen IX
Oil on canvas, 21 × 13 (8 ¹/₄ × 5 ¹/₈)
Private collection
(61)

The Birch Tree I 1901–2
Björken I
Oil on cardboard, 33 × 23 (13 × 9)
Private collection
(73)

Flower of the Moor 1901–2
Blomman pa heden
Oil on paper, 50 × 30 (18⅝ × 11⅞)
Private collection
(74)

Cliff I 1902
Falaise I
Oil on canvas, mounted on cardboard
20 × 11 (7¾ × 4⅜)
Nordiska Museet, Stockholm
(38)

Cliff III 1902
Falaise III
Oil on cardboard, 96 × 62 (27⅛ × 24½)
Nordiska Museet, Stockholm
(39)

Sunset 1902
Solnedgång
Oil on canvas, 13 × 21 (5⅛ × 8¼)
Private collection
(43)

The Cave (Inferno II) 1902
Grottan (Inferno II)
Oil on canvas, mounted on cardboard,
21 × 17 (8¼ × 6⅝)
Nordiska Museet, Stockholm
(63)

Landscape with Tobacco Flowers 1902
Landskap med tobaksblommor
Oil on canvas, 12 × 23 (4¾ × 9)
Nordiska Museet, Stockholm
(53)

Coastal Landscape II 1903
Kustlandskap II
Oil on canvas, 76 × 55 (30 × 21⅝)
Nationalmuseum, Stockholm
(40)

Rosendal Gardens 1903
Rosendals trådgård
Oil on canvas, 54 × 93 cm (21¼ × 36⅝)
Nordiska Museet, Stockholm
(76)

Sunset over the Sea 1903
Sol går ned uti hav
Oil on canvas, 95 × 53 (37⅜ × 20⅞)
Private collection
(41)

Sunset 1903
Solnedgång
Oil on cardboard, 40 × 29 (15¾ × 11⅜)
Private collection
(42)

Rosendal Gardens II 1903
Trädgården (Rosendals trädgård II)
Oil on canvas, 37 × 54.5 (14½ × 21½)
Göteborg Konstmuseum, Sweden
(79)

Apple Trees in Blossom 1903
Blommande äppelträd
Oil on cardboard, 17 × 13 (6⅝ × 5⅛)
Private collection
(75)

The Town 1903
Staden
Oil on canvas, 94.5 × 53 (37⅛ × 20⅞)
Nationalmuseum, Stockholm
(78)

The Avenue 1905
Allén
Oil on canvas, 94 × 53 (36⅞ × 20⅞)
Thielska Galleriet, Stockholm
(77)

PHOTOGRAPHS

Photographs from Gersau 1886
Fotografier ur den så kallade Gersausviten
Modern prints from original photographs
Original size, each 18 × 24 (7 × 9⅜)
Strindberg Museum, Stockholm
(81)

*Twelve Impressionist Images, the so-called
'Gersau Album'* 1886
Fotografialbum. Tolf Impressionist Bilder
Photograph album
36.7 × 25 (14½ × 9⅞) closed
Private collection
(85)

Photograms of Crystallisation 1892–6
Fotogram av kristallisation
Modern prints from original photographs
Original size, each 12 × 9 (4¾ × 3½)
The Royal Library, National Library of Sweden,
Stockholm
(83)

Celestographs 1894
Celestografier
Modern prints from original photographs
Original size, each 12 × 8 (4¾ × 3⅛)
The Royal Library, National Library of Sweden,
Stockholm
(82)

Self-Portrait 1892–3
Självporträtt
Photograph, 12 × 9 (4¾ × 3½)
The Royal Library, National Library of Sweden,
Stockholm
(84)

Self-Portrait 1906–7
Självporträtt
Photograph, 23 × 28.5 (9 × 11⅛)
Nordiska Museet, Stockolm
(80)

Photographs of Cloud Formations 1907
Molnformationer
Modern prints from original photographs
Original size, each 12 × 16.5 (4¾ × 6½)
The Royal Library, National Library of Sweden,
Stockholm
(87)

SCULPTURES

The Weeping Boy 1891
Den gråtande gossen
Plaster, 20 (7 ³/₄) high
Private collection
(102)

The Weeping Boy 1891
Den gråtande gossen
Gilded plaster, 20 (7 ³/₄) high
Private collection
(86)

Hanna Palme von Born 1891
Plaster, 18.5 (7 ¹/₄) high
Private collection
(6)

DRAWINGS AND MANUSCRIPTS

Landscape Study, Kymmendö 1872
Landskapsstudie, Kymmendö
Pencil on paper, 27 × 22 (10 ⁵/₈ × 8 ³/₄)
Göteborg University Library
(91)

Pine 1873
Kryptall
Pencil on paper, 16 × 23.2 (6 ¹/₄ × 9 ¹/₈)
Nordiska Museet, Stockholm
(3)

Twin Pines 1873
Tvillingtall
Pencil on paper, 15.6 × 10 (6 ¹/₈ × 3 ⁷/₈)
Nordiska Museet, Stockholm
(4)

Pine in the Archipelago 1873
Skärgårdsgran
Pencil on paper, 23.2 × 16 (9 ¹/₈ × 6 ¹/₄)
Nordiska Museet, Stockholm
(5)

Cottage with Turf Roof 1873
Parstuga med torvtak och utskjutande bakugn
Pencil on paper, 7.2 × 16 (6 ³/₄ × 6 ¹/₄)
Nordiska Museet, Stockholm
(92)

*Cover for the Draft Manuscript for
'The Secret of the Guild'* 1879–80
Gillets hemlighet, originalhandskrift
Ink and watercolour on paper
32.5 × 24.5 (12³/₄ × 9⁵/₈)
Mörnersamlingen (owner Örebro Public Library,
deposit in Örebro University Library)
(90)

Four illustrated letters to Carl Larsson (1881–94)
Ilustrerade brev till Carl Larsson, fem st.
Letter from August Stringberg to Carl Larsson,
19 June 1881
19.5 × 27(7⁵/₈ × 10⁵/₈)
Letter from August Stringberg to Carl Larsson,
13 April 1882
21 × 27 (8 ¹/₄ × 10 ⁵/₈)
Letter from August Stringberg to Carl Larsson,
29 January 1884
16.5 × 21 (6¹/₂ × 8¹/₄)
Letter from August Stringberg to Carl Larsson,
26 July 1884
11 × 17.7 (4³/₈ × 7)
Uppsala University Library
(2)

*Frottage, Paris c.*1890
Pencil on paper, 33 × 21 (13 × 8 ¹/₄)
The Royal Library, National Library of Sweden,
Stockholm
(103)

Tree Study 1890
Drawing on paper, 9.5 × 27 (3 ³/₄ × 10⁵/₈)
The Royal Library, National Library of Sweden,
Stockholm
(104)

Golden Book 1896
Livre d'or
Paper booklet, hand-bound with string,
containing samples of 'gold'
26.7 × 21.4 (10¹/₂ × 8³/₈)
Private collection
(105)

Frottage made from the Shell of a Crab 1896
Frottage av krabbskal
Pencil on paper, 9 × 10 (3 ¹/₂ × 3 ⁷/₈)
Private collection
(8)

*Three Sketches Depicting Partially
Burnt Lumps of Coal* 1896
*Tre Koltechningar föreställande delvis
förbrända kolstycken*
Charcoal on paper, 8.8 × 6 (3 ¹/₂ × 2 ¹/₄),
6.2 × 10 (2 ³/₈ × 3 ⁷/₈), 8.6 × 9.2 (3 ³/₈ × 3 ⁵/₈)
Private collection
(7)

Manuscript for 'Inferno' 1897
Munuskript till Inferno I
Ink on paper, 25 × 20 (9⁷/₈ × 7³/₄)
Göteborg University Library
(106)

*Landscape with Pine Trees c.*1900
Crayon on cardboard
16.5 × 25 (6¹/₂ × 9 ⁷/₈)
Nordiska Museet, Stockholm
(94)

Stage Set for Mary Stuart, sketch c.1903
Drawing on paper, 17.5 × 21 (6⁷/₈ × 8¹/₄)
The Royal Library, National Library of Sweden,
Stockholm
(89)

Ink Blot Picture. Enclosure to the Occult Diary
1904
Kleksografi (bilaga till Ockulta dagboken)
Ink on paper
18 × 22 (7 × 8³/₄)
The Royal Library, National Library of Sweden,
Stockholm
(13)

Cloud Formations 1907
Molnformationer
Pencil on paper, 11 × 19 (4³/₈ × 7¹/₂)
The Royal Library, National Library of Sweden,
Stockholm
(88)

OTHER MATERIAL

The Gersau Camera 1886
Wood, brass, pearl, ivory,
13 × 19 × 15 (5 1/8 × 7 1/2 × 5)
Strindberg Museum, Stockholm
(107)

Painting Box, including Palette 1894
Oak, brass, 7 × 27 (2 3/4 × 10 5/8)
Strindberg Museum, Stockholm
(108)

*Catalogue for the Paul Gauguin Auction, Paris,
February 1895, with Foreword by August
Strindberg* 1895
Printed leaflet, 24 × 15.5 (9 3/8 × 6 1/8)
The Royal Library, National Library of Sweden,
Stockholm
(109)

Scientific Instrument for Chemical Purposes 1900
Brass, iron, 16 (6 1/4) high
Strindberg Museum, Stockholm
(110)

Scientific Instrument 1900
Brass, 36 (14 1/8) high
Strindberg Museum, Stockholm
(111)

Glass Bowl Used for Making Gold c.1897–9
Glass, 41 (16 1/8) high
Museum for Science and Technology, Stockholm
(99)

*Reproduction of a painting by Turner
(The Fighting Temeraire)* n.d.
Lithograph, handcoloured,
22 × 29 (8 3/4 × 11 3/8)
The Royal Library, National Library of Sweden,
Stockholm
(11)

*Reproduction of a painting by Turner
(The Sun of Venice Going to Sea)* n.d.
Lithograph, handcoloured,
19.5 × 28 (7 5/8 × 11)
The Royal Library, National Library of Sweden,
Stockholm
(112)

*Copy of William Shakespeare's 'Sonnets' with
Annotations by Strindberg* n.d.
Book, 17 × 12.5 × 1.5 (6 5/8 × 4 7/8 × 5/8)
Nordiska Museet, Stockholm
(113)

WORKS BY OTHER ARTISTS

Edvard Munch 1863–1944
August Strindberg 1892
Författaren August Strindberg
Oil on canvas, 122 × 91 (24 × 35 7/8)
Moderna Museet, Stockholm.
Gift 1934 from the artist
(10)

Edvard Munch 1863–1944
August Strindberg 1896
Lithograph, 60.5 × 46 (24 1/8 × 18)
Munch-museet, Oslo
(95)

Carl Larsson 1853–1919
August Strindberg 1899
Charcoal and oil on canvas
56 × 39 (22 × 15 3/8)
Nationalmuseum, Stockholm
(93)

Carl Eldh 1873–1954
Strindberg Walking 1904
Strindberg på promenade
Bronze, 41 (16 1/8) high
Moderna Museet, Stockholm.
Gift 1953 from Moderna Museets Vänner
(12)

Carl Eldh 1873–1954
Portrait of the Writer August Strindberg 1905
Porträttbyst av författaren August Strindberg
Bronze, 64 (25 1/4) high
Moderna Museet, Stockholm
(97)

Herman Anderson 1856–1909
August Strindberg c. 1906–8
Photograph, 30 × 23 (11 7/8 × 9)
Strindberg Museum, Stockholm
(114)

Herman Anderson 1856–1909
August Strindberg 1908
Modern print from original glass negative
in the Royal Library, Stockholm
Original size: 12 × 8 (4 3/4 × 3 1/8)
Strindberg Museum, Stockholm
(14)

Carl Eldh 1873–1954
The Young Strindberg in the Archipelago 1908
Den unge Strindberg is skärgården
Plaster, 41 (16 1/8) high
Carl Eldhs Ateljémuseum /
The Carl Eldh Studio Museum, Stockholm
(96)

Herman Anderson 1856–1909
Portrait of August Falck 1908
Fyra porträtt av August Falck
Photographs, 34 × 28 (13 3/8 × 10 7/8)
(nos.12–14),
31 × 25 (12 1/8 × 9 7/8) (no.11)
Strindberg Museum, Stockholm
(98)

Anders Zorn 1860–1920
August Strindberg 1910
Etching, 29.9 × 19.9 (11 7/8 × 7 3/4)
Nationalmuseum, Stockholm
(100)

Lenders

Photo Credits

Index